# THE BEST OF
# COLORED PENCIL

VOLUME FIVE

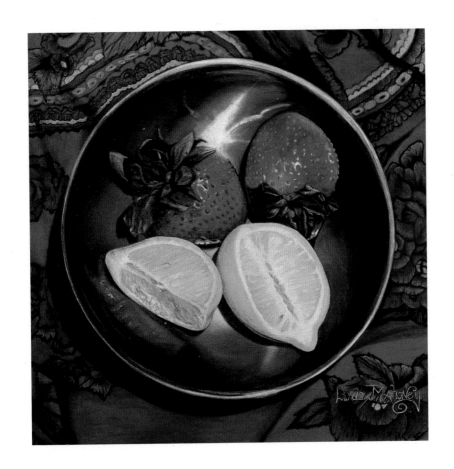

ROCKPORT

First published in the United States of America by:

Quarry Books, an imprint of

Rockport Publishers, Inc.

33 Commercial Street

Gloucester, Massachusetts 01930-5089

Telephone: (978) 282-9590

Facsimile: (978) 283-2742

Distributed to the book trade and art trade in the United States by:

North Light Books, an imprint of

F & W Publications

1507 Dana Avenue

Cincinnati, Ohio 45207

Telephone: (800) 289-0963

Other distribution by:

Rockport Publishers, Inc.

Gloucester, Massachusetts 01930-5089

ISBN 1-56496-582-1

10 9 8 7 6 5 4 3 2 1

Design: Sawyer Design Associates, Inc.

Cover Image: Barbara Newton, CPSA. *Debut: Lemons (see pg.21)*

Printed in China.

# THE BEST OF
# COLORED PENCIL

VOLUME FIVE

GLOUCESTER MASSACHUSETTS

ROCKPORT
PUBLISHERS

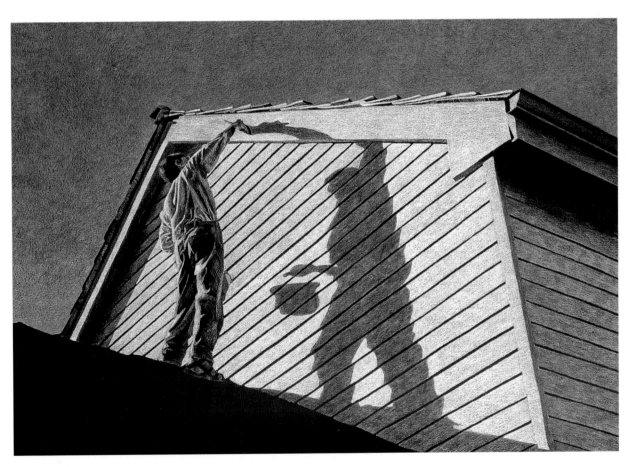

**PAMELA BELCHER**
*Painting Partner*
11" x 17" (28 x 43 cm)

# INTRODUCTION

The colored pencil drawings presented at the CPSA International Colored Pencil Exhibition, which was held at the modern Ellipse Art Center in Arlington, Virginia, displayed a barrage of colors, kinetic energy, innovative styles and incredible techniques that overwhelmed and inspired the hundreds of guests attending this opening. The show was an array of talent culled from approximately 900 entries by Juror M. Stephen Doherty, Editor-in-Chief of *American Artist* magazine. Each two-dimensional artwork of pure colored pencil brought audible responses and beckoned viewers to stop, discover, and return again and again to scrutinize the personal "imprints" made by artists from around the country.

This aesthetic feast—accompanied by a real feast of food, wine, and hospitality—was hosted by the gallery staff and its Director, Trudy VanDyke, who graciously greeted and served the burgeoning crowd during this event. Trudy's contributions—from inception to installation—maintained the professional standards warranted by the art and artists and provided a high point to our convention.

It was a full week of camaraderie, meetings, workshops, and banquets. There was an ongoing series of activities—some casual, some formal. But what appeared to be an effortless week of events was actually a year in the making. It was Susan Brooks, CPSA Exhibition Director, whose close attention to detail helped orchestrate all the events. No idea was too large and no detail was too small. Susan tackled it all. However, there are so many other people I would also like to acknowledge—from the members of the national board and the host of the Metro Washington District Chapter to the sponsors, patrons, and artists. All of you played an essential role in the exhibition's success.

And in the center of this whirlwind lies the heart of it all—the colored pencil artwork. This book provides you with a private tour, one in which you will be able to meditate on each work. The artists' personal comments have been included to take you beyond the visual surface and into the depths of its creation.

This is art at its finest. This is colored pencil at its finest.

—Vera Curnow, *Founder*
Colored Pencil Society of America

The quality and variety of work entered in this competition testifies to the advances made by artists working with colored pencil. I feel strongly that the pictures I have selected for the exhibition and for the awards have as much depth of expression, inventiveness in the use of the medium, and seriousness of presentation as any artwork I have seen in other media. Clearly, colored pencil has come into its own through the efforts of the Colored Pencil Society of America (CPSA) and the individual artists using the medium.

This competition, the exhibition and publication resulting from it, and the convention organized by the CPSA provide an opportunity for artists to learn from each other, a condition critical to continued growth. We all need to learn about new materials, new techniques, and new applications for colored pencil. We also need to be challenged by the best artists in the field.

I was most impressed with the work of artists who began with a recognizable image and devised a unique way of presenting it in colored pencil. That is, they showed me a new way of seeing a familiar subject. One person enlarged a baby's head to gargantuan scale and rendered the supple skin with hatched and cross-hatched lines. Another turned elements of a Southwestern landscape into a quilt of patterns, textures, and colors. And another artist rendered a simple paper bag as if it were a rare piece of sculpture. The number of abstract and semi-abstract pictures entered in the competition is a healthy indication that colored pencil artists are exploring new forms of expression. In the process of inventing their presentations, the artists showed me something about themselves and the world we share.

The weakest entries in the competition were those that either failed to realize the potential of the medium or those that slavishly transferred a snapshot into a colored pencil drawing. And there were those subjects I see so often that it becomes difficult for me to recognize any individuality in the presentation. Among those subjects are close-up views of flowers, static still-life compositions, and renderings of family photographs.

I thank the CPSA for this extremely valuable opportunity to review the best work being done in colored pencil. I'm certain the experience will influence my work as Editor-in-Chief of *American Artist* magazine, and I look forward to sharing information about the CPSA and its members with readers of the publication.

—M. Stephen Doherty, *Editor-in-Chief*
*American Artist* Magazine

## VERA CURNOW, CPSA

*Interior Motives*

20" x 15" (51 x 38 cm)
Crescent Cold Press Illustration Board

It's just a pencil. But the operative word for this tool is control. Touch it to paper and it makes a mark—in the color of your choice, in the exact location you want. No drips, stains, or spatters. And no surprises. This medium is so manageable that most artists rarely find the need to erase or to even scrap a work in progress. However, I'm proud to say that I erase, scrub, scratch, slash, rework, and even demolish many of my drawing experiments. In fact, it's not the finished work that motivates me, but the act of doing. Indeed, art is a product, but for me, being an artist means being in the process.

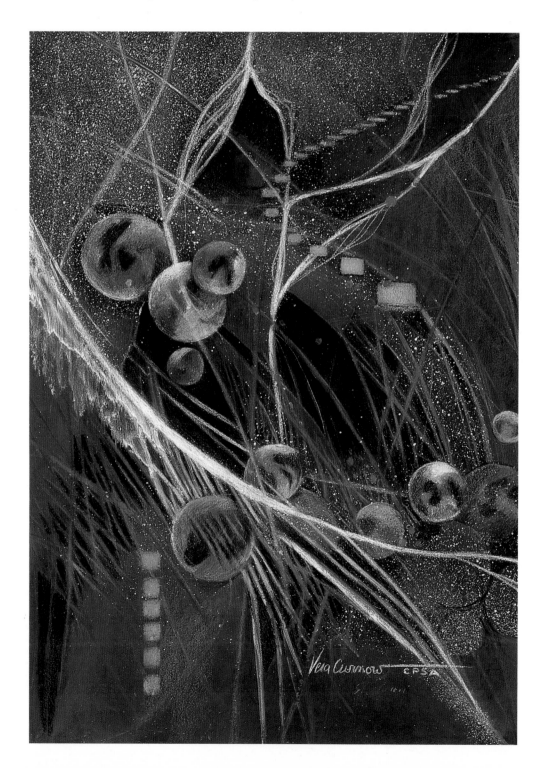

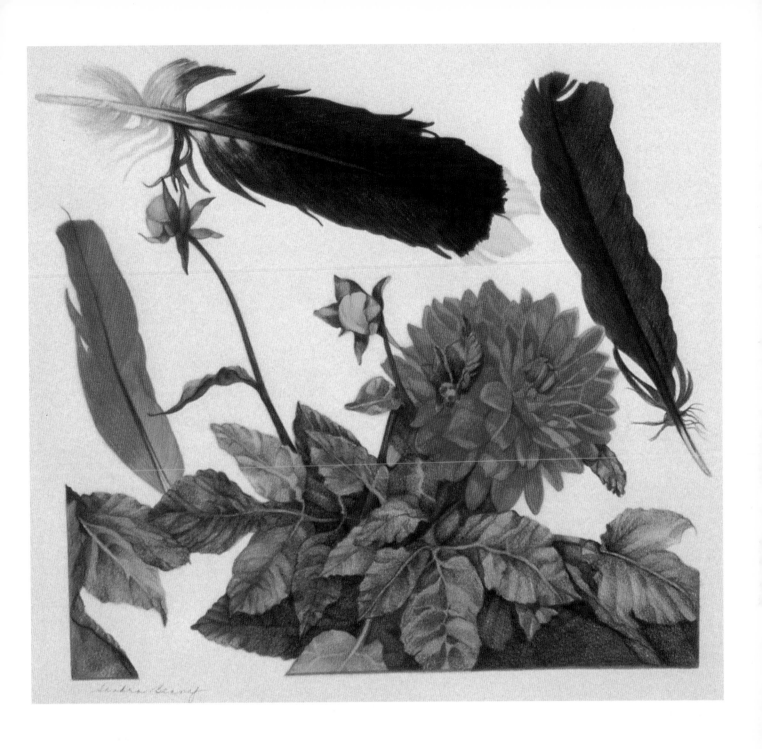

**SANDRA BENNEY**

*Dahlia*

18" x 20" (46 x 51 cm)

100% Rag 4-Ply Museum Board

My work is inspired by the woods in which I live. Every turn of the head reveals a new picture. In *Dahlia*, the combination of nature and bird feathers, rendered with warm and cool colors, symbolize air and land. I enjoy "pushing and pulling" the flat drawing surface to create different sensations of space and light. I want to create a place of refuge and peace for the viewer and enjoy relating my feelings of joy and celebration of all living things.

**LYNN A. BYREM, CPSA**

*Golden Memories*

11" x 16" (28 x 41 cm)

Bienfang Art-Vel 211-Translucent Tracing Paper

After three years of working on still lifes involving intricate lace, I needed a break. These carousel horses, caught in the sunlight, were photographed during a family outing at a small amusement park. The variety of colors and values—reflected in the white horses—were captured by burnishing many layers of mixed color, creating a smooth, slick texture. I rendered the background with a soft tonal application to contrast with the glossy finish of the horses. Personally, the carousel holds a special place in my life, bringing back golden memories of playfulness and youth.

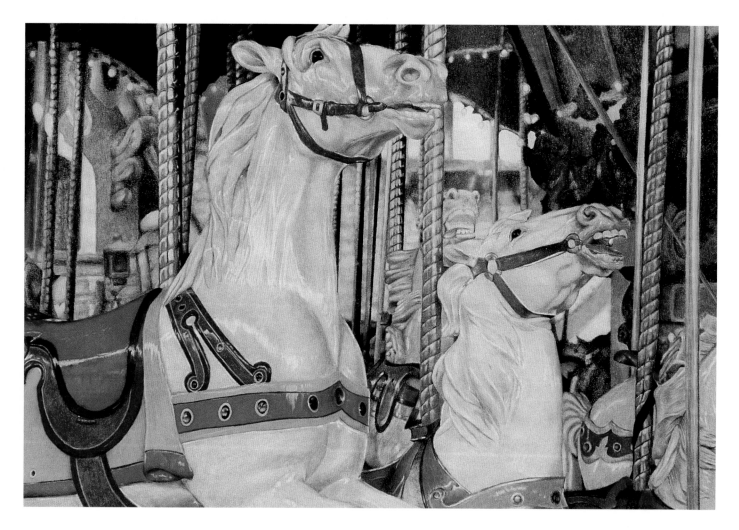

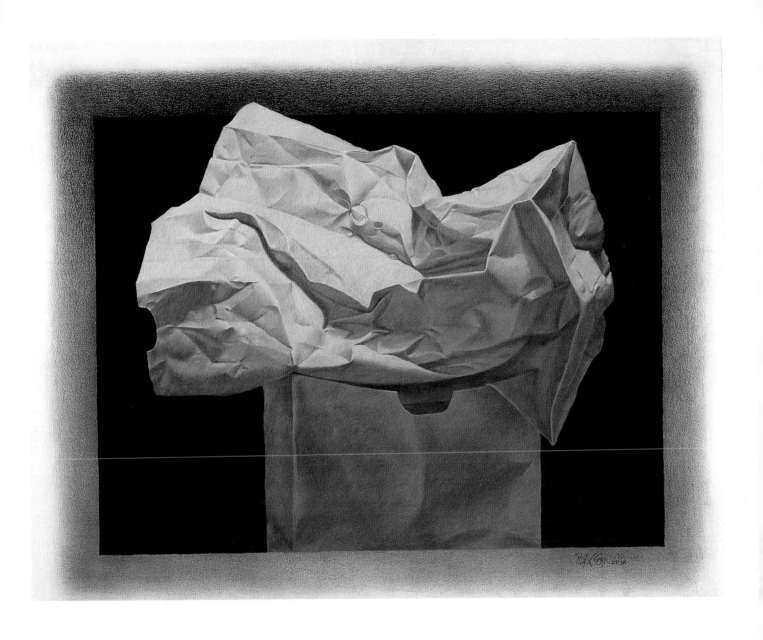

### JOE BASCOM, CPSA

Memphis DC Award of Excellence

*Brown Paper Bag No. 103*

23" x 29" (58 x 74 cm)

Strathmore Acid Free 3-Ply, White

This is an ongoing series depicting a common object. Each drawing begins with the same unvarying conditions using a six-pencil palette and is rendered directly from life. I find, however, that the subject, the brown paper bags, can take on very suggestive, anthropomorphic qualities. They, like people, have an "outside" and "inside;" a "front," "back," "top," and "bottom." They can even be manipulated into human-like shapes and relationships. I believe, as Walt Whitman did, that we can be as baffled by the simplest aspects of the universe as well as the most complex.

## DODIE SETODA

*Light Weavings*

12" x 17" (30 x 43 cm)

Rising 2-Ply Museum Board, Black

Very early on a cold winter morning, with a steaming coffee cup in my hand, I sat in my favorite chair. And the image presented itself to me. The sun shown through the window and illuminated this grouping that had been set on my fireplace hearth. The colors glowed, and the scene demanded my attention. Strangely enough, as I worked, I felt as though the image was already in the black paper—slowly revealing itself to me. I loved doing *Light Weavings* with its lost and found edges, varying shapes, textures, and patterns. While others may fill their baskets with "things", I enjoy the baskets themselves. In today's fast-paced electronic world, basket weaving retains the human touch. My collection is growing.

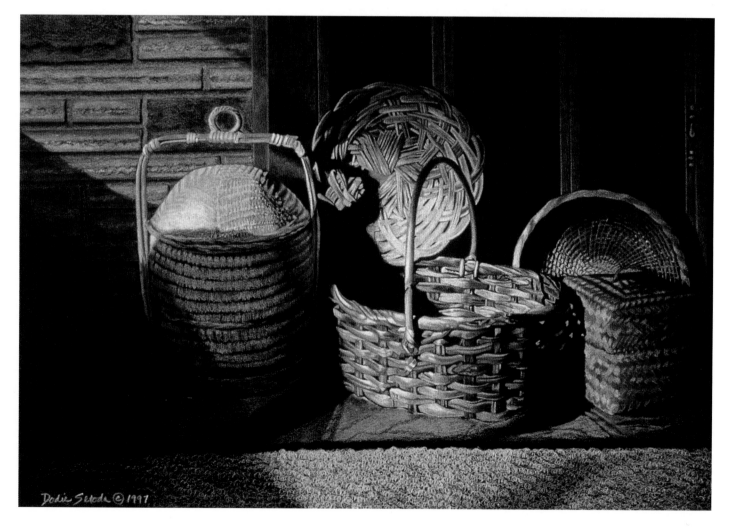

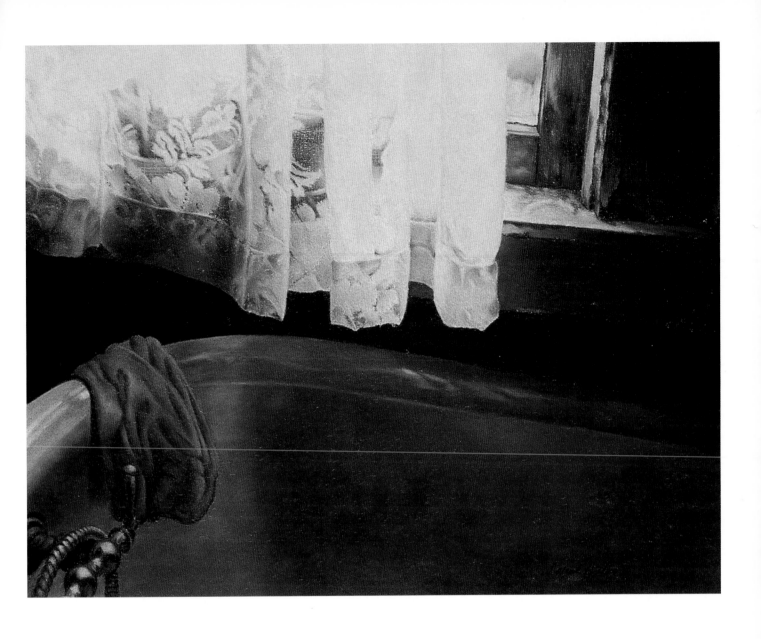

### CAROL BAKER, CPSA

*The Bath*

14" x 17" (36 x 43 cm)
Rives BFK 250 Printmaking Paper, White

I am drawn to simple, unpretentious subjects. This composition attracted me because of its dramatic contrasts—the soft, delicate curtain next to the rough, deteriorating wood sill or the smooth hardness and architectural lines of the bathtub next to the fragility of the lace. With the use of intoxicating color, play of light and shadow, crucial placement of objects in relation to each other and the paper's edge, I strive to add interest and mystery to my common scenes.

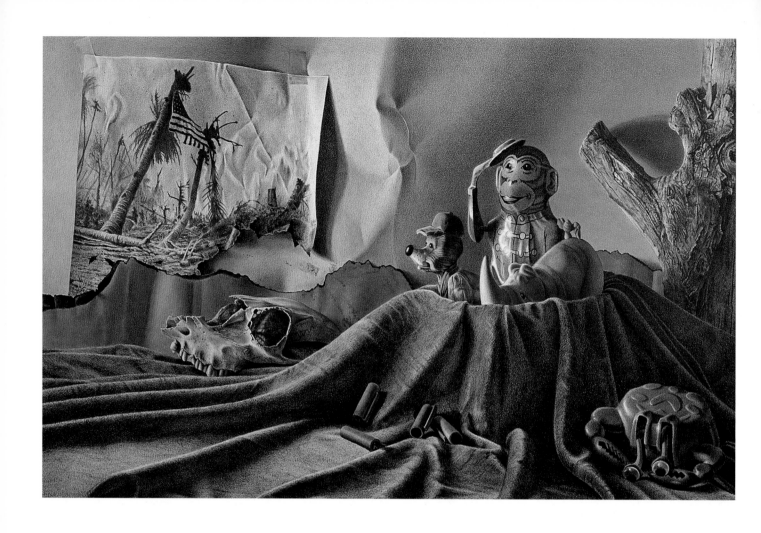

**RICHARD HUCK, CPSA**

*Hold At All Costs*

19" x 30" (48 x 76 cm)
Arches 260 lb. Hot Press, White

"Hold at All Costs" is part of a series that evolved over the several years. This painting interprets a World War II battle that my father, who died when I was a teen, fought bravely in but never talked about. After corresponding numerous times with the military, I was informed of how my father received the Bronze Star. My artistic goal is to connect intellectually or emotionally with the viewers, leaving them to make their own interpretations of the artwork. I used toys in place of soldiers, cloth instead of earth, hoping to create a symbolic scene to which a broad spectrum of individuals can relate.

**SHIRLEY STALLINGS, CPSA**

*Baubles, Bangles, And Boats*

14" x 16" (36 x 41 cm)

Rising 4-Ply Museum Board, White

While spending a day at a marina, a fishing boat moored across from us with brightly colored fenders hanging along its side. Not only did the boat reflect in the water, but also the ripples of water reflected back onto the hull. Since I am not a photographer, my references are usually not in focus and have washed-out color and unresolved compositions. My photographs for this painting are good examples of this. They didn't capture the color and brightness I remembered. But they did offer inspiration. Perfect photographs are completed pictures that need only to be reproduced; working with distortions compels me to work more creatively.

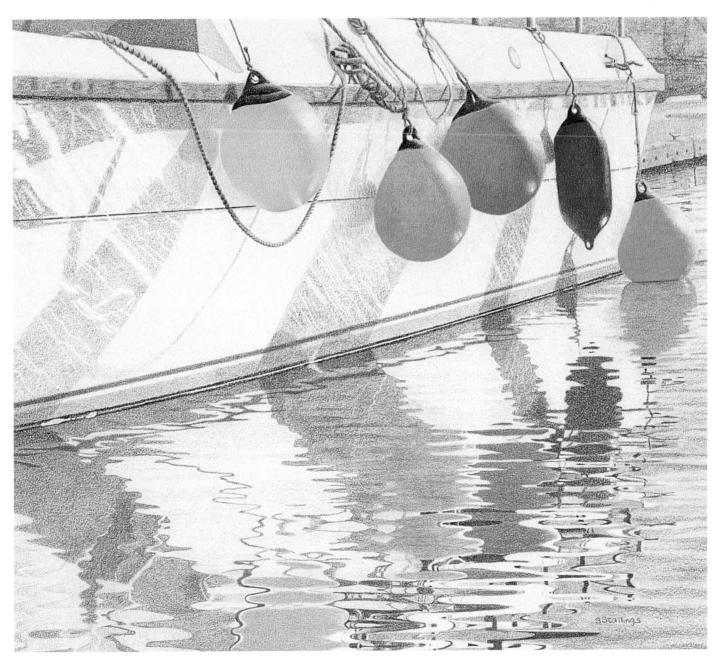

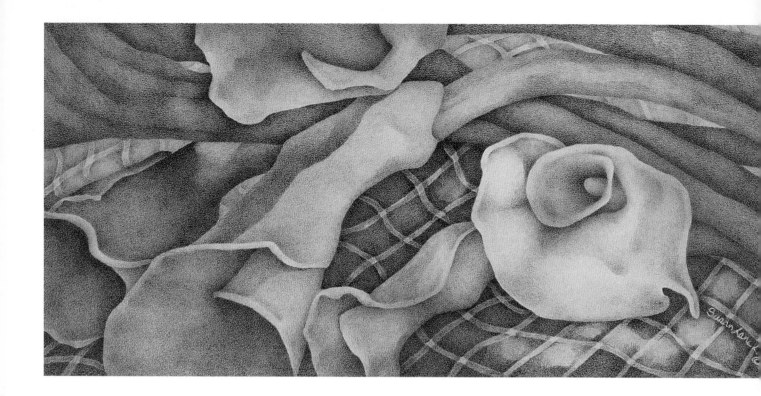

**SUSAN LANE GARDNER**

*Calla Lillies In Gray*

8" x 19" (20 x 48 cm)

Strathmore 4-Ply Museum Board, White

Calla Lillies are elegant flowers; I am drawn to their simple lines. One of my goals with this drawing was to achieve a stronger contrast between light and dark. I first completed a graphite value study to help me push the darks and create a path of light through the work. Translating this to color lead me to the idea of working in contrasts of warm and cool gray, black, and the white of the paper. While I don't always work with just achromatic colors, it is an interesting process and an important step for me to take periodically.

**HELEN JENNINGS**

*Second Look*

23" x 19" (58 x 48 cm)

Strathmore 4-Ply Plate Finish, White

I have painted for years. So, it seems only natural that I use colored pencils in the same way I use my paints. I can't make a seemingly black area just black. I see blues, greens, yellows, reds—lots of delicious colors to describe a zebra's stripes. I'm told that what sets my wildlife art apart from other artists is my use of color and my impressionistic style. Since I don't want cages, fences, or anything suggesting captivity in my animal series, I have turned the dark fence in this drawing (which is in the background) into an abstract movement of colors.

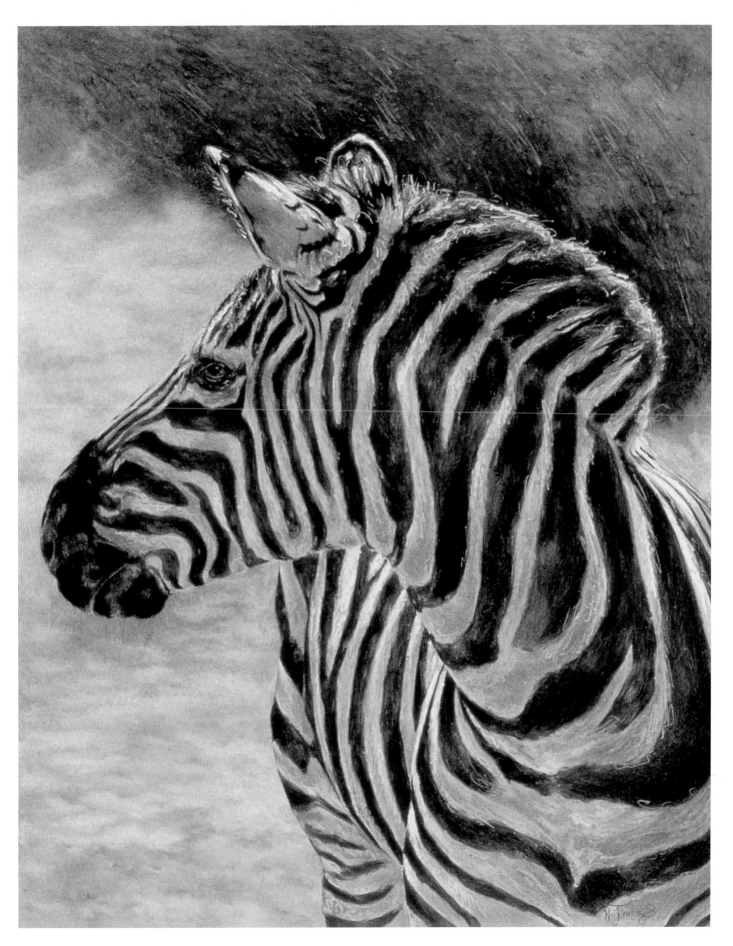

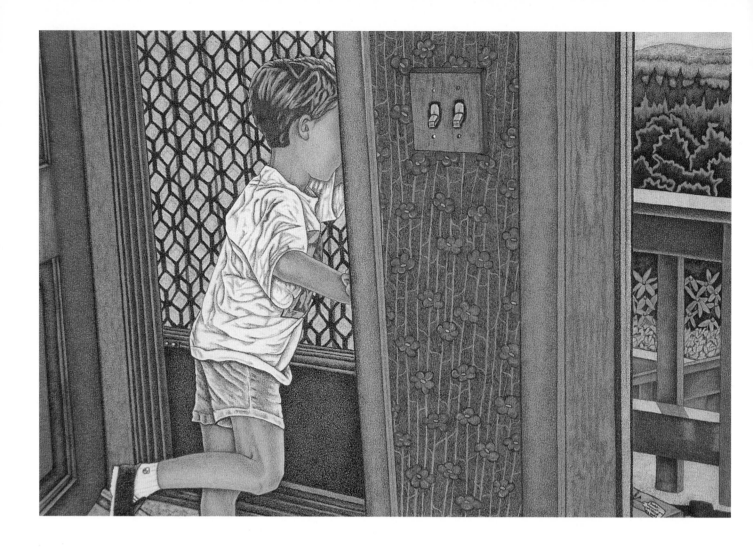

**BARBARA HERKERT**

*"Don't Slam The...!"*

11" x 17" (28 x 43 cm)

Rising 2-Ply Museum Board, Antique White

My busy, active, eight-year-old son, Keith, is a constant source of inspiration and enlightenment. The intent of this piece is to capture the speed and excitement of my son's universe. The boy is leaving his home and entering a world of enchantment where the possibilities for adventure are limitless. He rushes out the door, barely hearing his mother's famous last words.

**J. CORINNE JARRETT**

*"It Was A Long Day At The Beach"*

9" x 8" (23 x 20 cm)

Rising 2-Ply Museum Board, White

I found this photograph of my daughter, Rebecca, taken when she was nine. I loved the reflection of the sunset on her face. Her sunburned nose, tired eyes, and windblown hair made an inviting change from the usual "say cheese and look at the camera" type of portrait. It is especially meaningful to me that this piece was selected for the International Colored Pencil Exhibition. Rebecca is now 24 years old and has just recently moved 3,000 miles away from me to live closer to her sister in New York. To think that someone else saw something in that tired little face of so long ago fills my lonesome heart with immense pleasure.

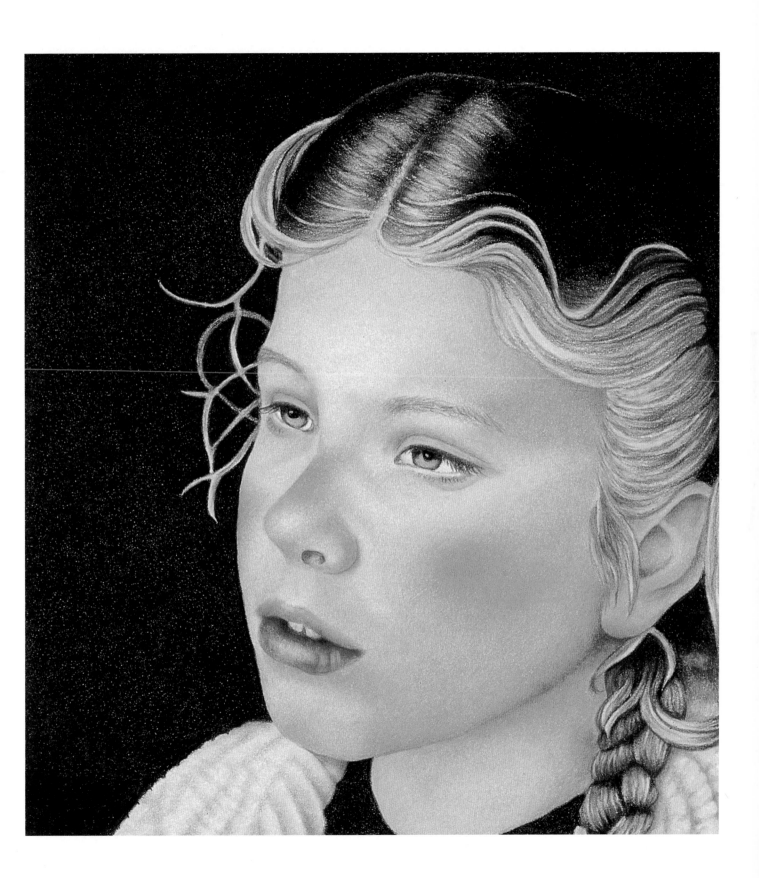

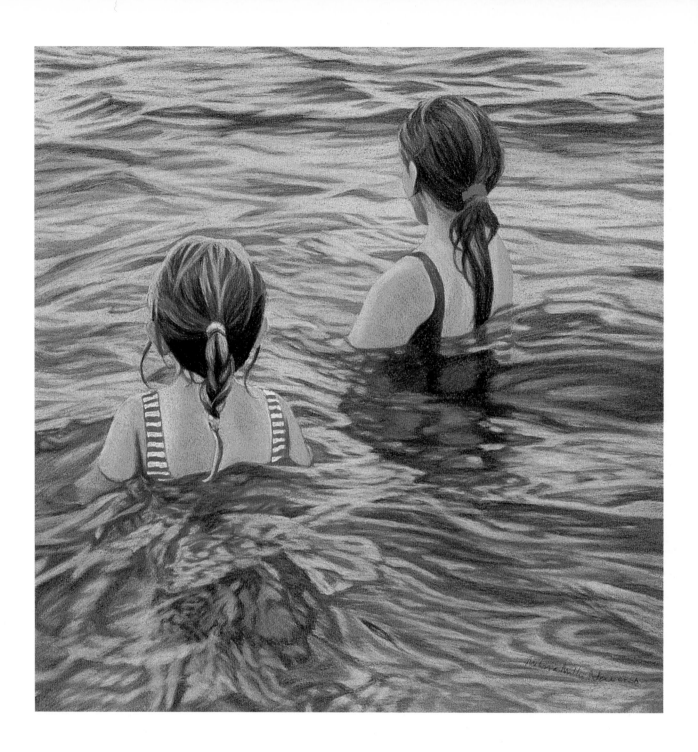

## MELISSA MILLER NECE, CPSA

*Sunset Swim*

13" x 13" (33 x 33 cm)
Canson Mi Tientes, Poppy Red

My paintings usually feature members of my family, but my intent is to develop imagery that could be recognized as anyone's family. This piece continues a series based on photos taken at the beach near my home. I used a disposable camera for the casual "vacation-snapshot" quality that these cameras produce. (I also didn't want to ruin an expensive camera by getting sand or salt water on it.) What is distinctive about this piece is the visual vibrations created by using a visually aggressive red paper under a complementary palette of predominantly gray-green colors. Unexpectedly, it also produced a lovely glow reminiscent of a Gulf of Mexico sunset, hence the title. But the truth is the photo was taken at midday.

## BARBARA NEWTON, CPSA

CPSA Award of Excellence

*Debut: Lemons*

20" x 19" (51 x 48 cm)
Strathmore 3-Ply 500 Bristol Plate, White

There was a time when I felt I needed to change subjects, and that I had exhausted the possibilities of fruits and vegetables. But, I soon realized I had explored only the external surfaces of these beautiful objects. A change wasn't needed, but a closer look was. I had only begun to know the potential of my subjects. Beauty may be skin deep, but what about inner beauty? For "Debut: Lemons," I cut through the lemon's tough exterior to reveal the vulnerability within. And the glass lemon squeezer suggests the lemon's possible "fate".

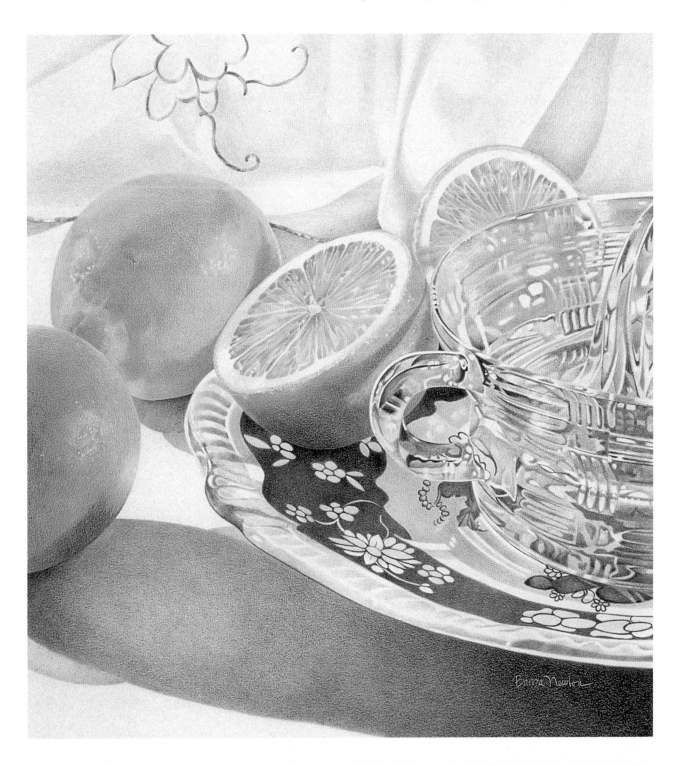

SHARON TIETJEN-PRATT

The Artist's Magazine Award of Excellence

*Great Expectations I*

12" x 14" (30 x 36 cm)

Strathmore 4-Ply Museum Board, White

While I wish that I could say that the idea for "Great Expectations I" emerged from careful planning and deliberation, it was quite the contrary. This piece depicts one of those rare and wonderful "artist's moments." It began with a simple handful of cherries being hastily washed and placed upon a tile counter; and it evolved into an adventure in line, color, texture, shape, and form. My goal was to create this image with as much detail, depth, and dimension as possible in a realistic style.

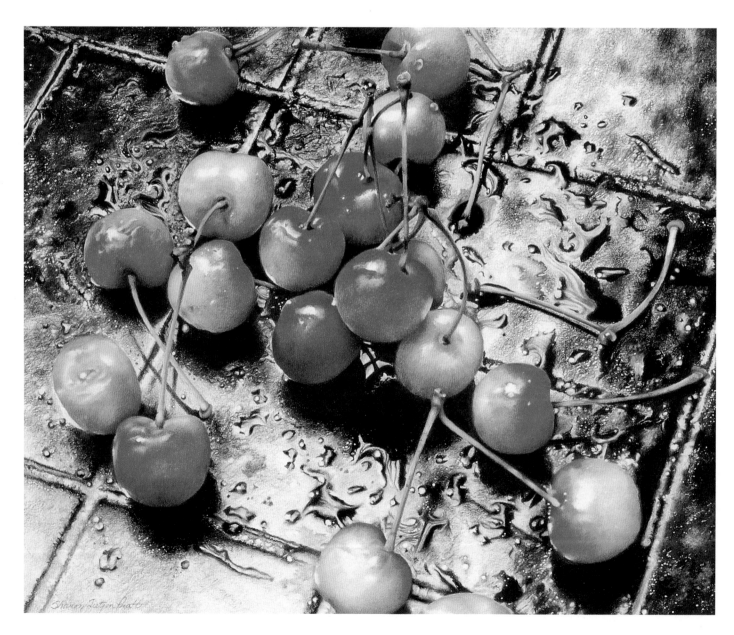

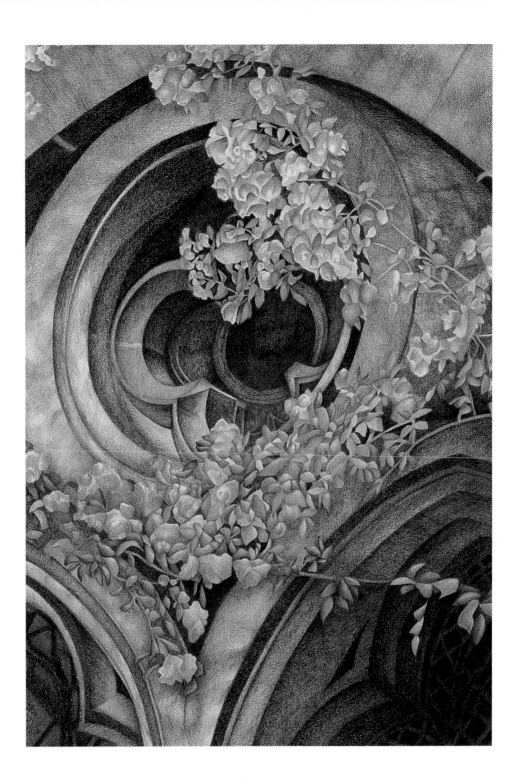

**JAN RIMERMAN, CPSA**

*Rodin's Garden Window*

30" x 20" (76 x 51 cm)

Strathmore Bristol 3-Ply Vellum, White

Generally, I don't do architectural renderings. But I was lulled into the challenge when I came upon this treasure of a small chapel in the Rodin gardens in Paris. The perspective and intimate setting projected a sense of timelessness and reminded me that someone a hundred years ago shared this view. This intrigued me, as did the stone texture and three-dimensionality of the structure. As in all my work, I strive to give the audience an intimate moment of an extraordinary scene, frozen in time. It's a scene one might have otherwise passed by.

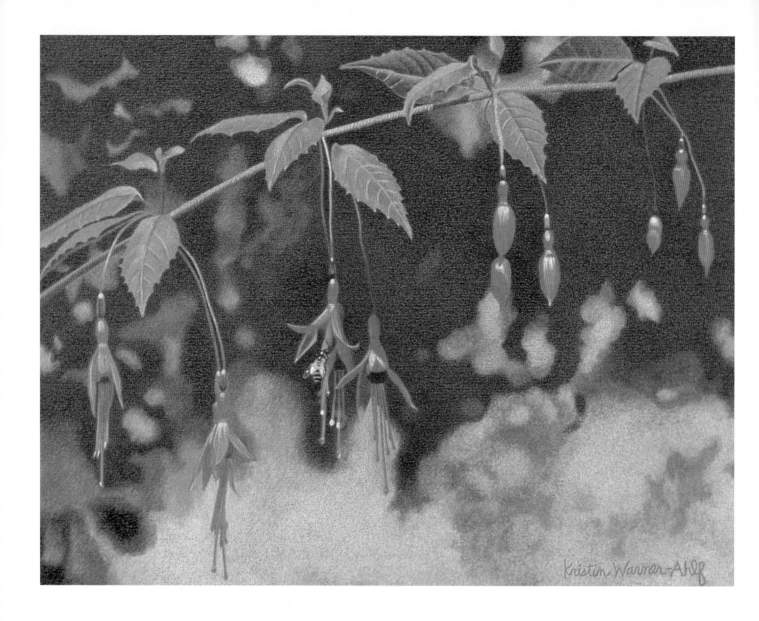

## KRISTIN WARNER-AHLF

*Fuchsia Visitor*

7" x 9" (18 x 23 cm)

Strathmore 500 Pastel Paper, Red

As in all my work, I look for a unique presentation of something that is understated or overlooked. The original background of this fuchsia was filled with competing visual elements—a tall fir tree, a body of water, shore, land, and sky. Rather than depict any recognizable shapes of the flowering plant's surroundings, I interpreted the backdrop as an abstract design to create a strong feeling of space and to highlight the focal point. By choosing a solid red paper for this piece, I found the deep intensity added more drama and mood to my style. I endeavor to paint not just the land or its plant life, but the poetry of its spirit.

## LAURA WESTLAKE

*Bluejays First Autumn*

18" x 27" (46 x 69 cm)

Strathmore 500 Bistol Vellum, White

As a licensed wildlife rehabilitator, I was, in a way, lucky to have two orphaned nestlings come into my care until it was time to release them three months later. Young and tame, they made perfect specimens and posed very well for the camera. It was early autumn, and soon after the arrival of the birds, the pumpkins came. The thought of blue and orange excited me. Consequently, the painting is about complementary colors. However, it is also about my love and concern for wild birds. I feel this work enabled me to educate the public on the bluejays' nature and their need for preservation.

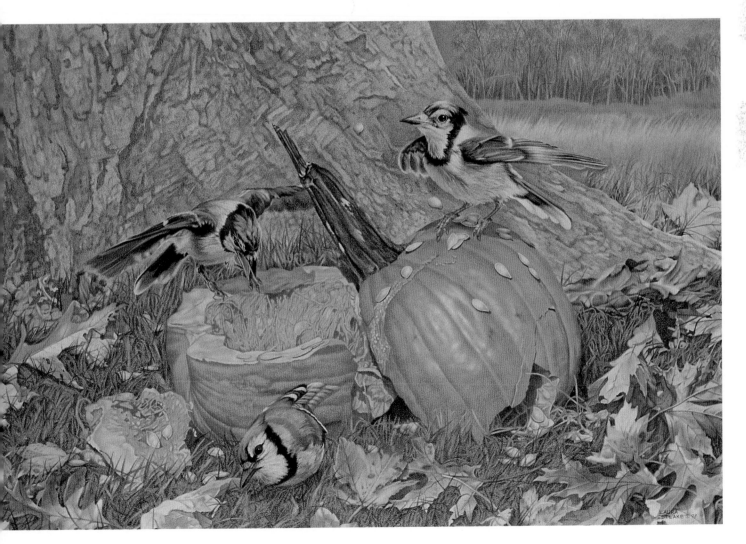

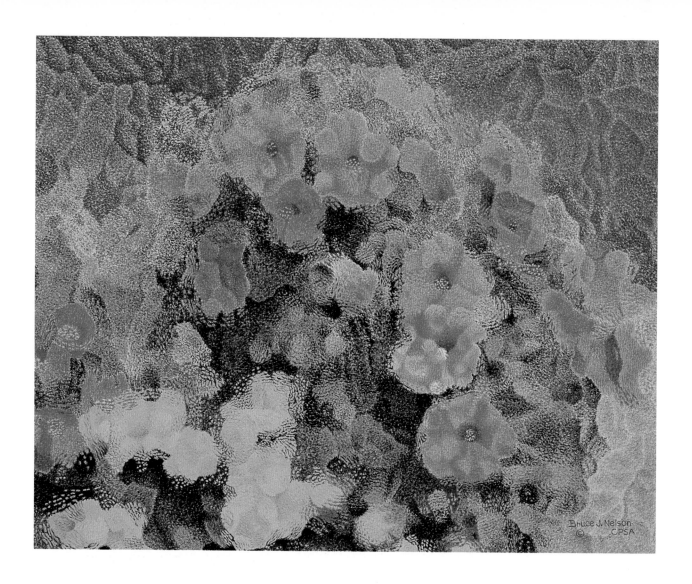

**BRUCE J. NELSON, CPSA**

*Flowers Of Summer*

16" x 20" (41 x 51 cm)

Rising 2-Ply Museum Board, White

My pointillist technique (the building up of dots of one color over another) and a piece of shower glass were used to transform a tub of flowers in our front yard into a work of art. I draped an old, blue tarp loosely behind the subject, propped up the glass in front of the flowers, and took several reference slides. It's a labor-intensive process, which is why I've only done three paintings in this style during the past ten years.

**LINDA J. MAHONEY**

*Primary Colors At High Noon*

17" x 17" (43 x 43 cm)

Strathmore 4-Ply Museum Board, White

My original attraction to this composition was in setting up contrasting elements: the bowl's reflective, deep blue interior surrounds the colors of the lemons and strawberries. These primary colors became my main focus. The direct view into the bowl provided a very elemental, limited composition: a circle (the blue bowl) centered within a square (the paper's edge).

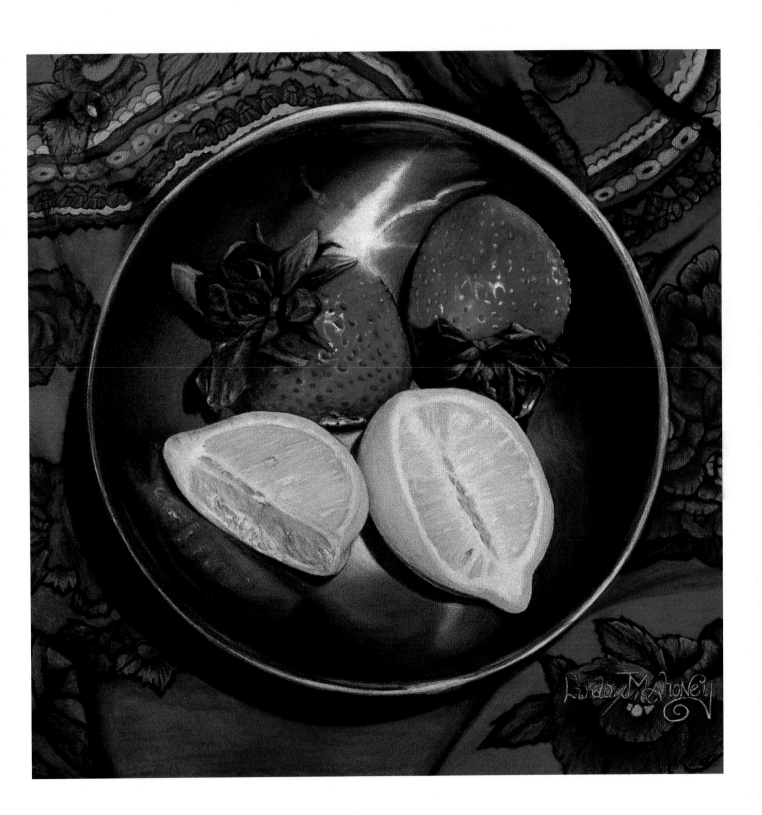

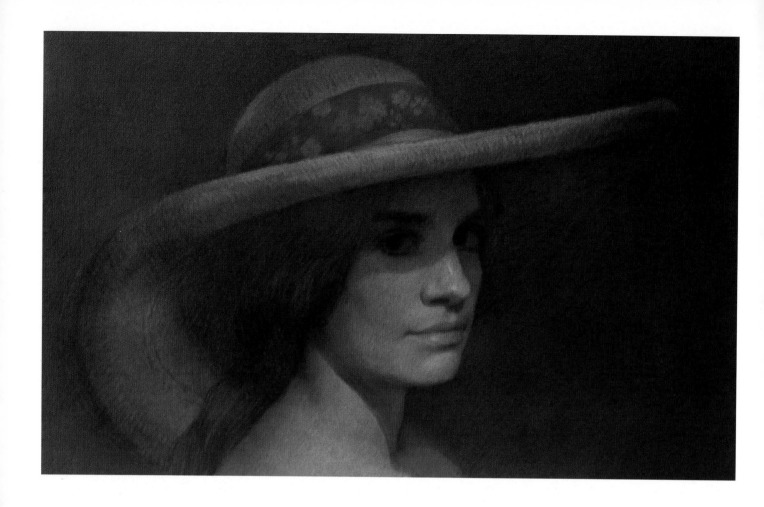

**RITA MACH SKOCZEN, CPSA**

Rockport Publishers Award of Excellence

*Sombrero*

12" x 19" (30 x 48 cm)
Canson Mi-Tientes, Dark Green

Although most of my work is done in front of a live model, it is finished using photographs. In this artwork, the focus is the light. It falls just below the brim and across the face of this beautiful girl. And the sombrero contributes to the piece without dominating it.

**DONNA GAYLORD, CPSA**

Bruynzeel Award for Outstanding Recognition

*Barrel's Crowning Achievement*

29" x 21" (74 x 53 cm)
Strathmore 4-Ply Museum Board, White

I have watched this particular cactus grow and change over a twelve-year period. Slowly, its crest bent, twisted, weathered, changed shape, and grew. I photographed it during different seasons and at different times of day. Because my art deals more with how I feel about a subject rather than creating a precise rendering of it, I designed *Barrel's Crowning Glory* to tell a story about this cacti and its strange texture, magnificent flowers, and, to the one creature who depends on it as a food source, succulent fruit.

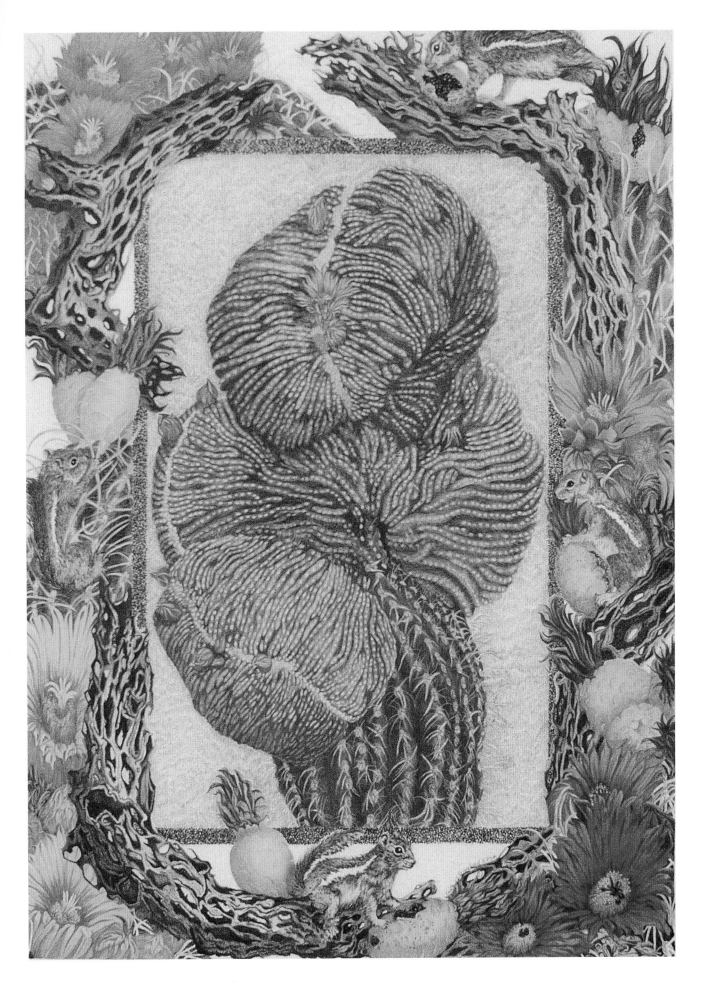

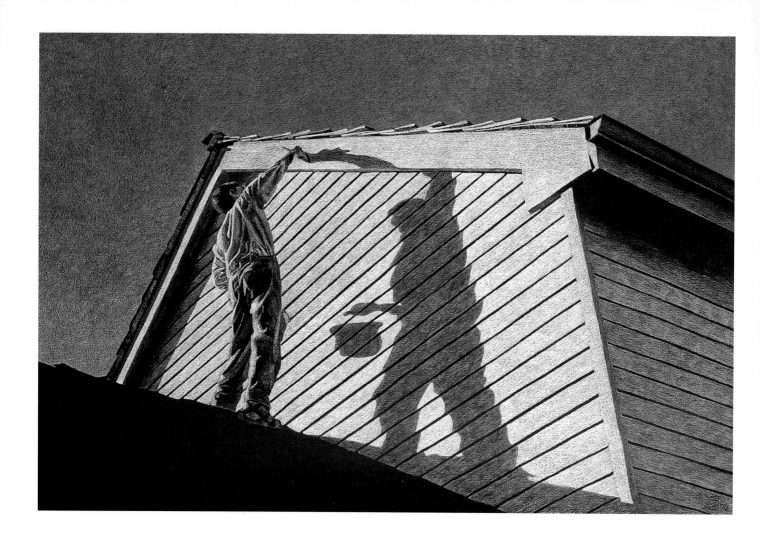

**PAMELA BELCHER**

*Painting Partner*

11" x 17" (28 x 43 cm)

Strathmore Recycled 601, Coal Black

As my husband stood on our very steep roof to paint the house trim, I watched him in case he fell off. I scrutinized his every move. Suddenly, the shape of his shadow popped into my vision and created some very interesting negative spaces. It was this "composition" that gave me the idea for the drawing.

**CIRA COSENTINO, CPSA**

*Lime Rickey's*

22" x 17" (56 x 43 cm)

Stonehenge Paper, White

In Toronto, I visited this funky, 50's style diner with lots of character. I knew it would make a great subject, but I wasn't sure which part of it I wanted to render. There were many views that would have made a great picture, but I decided to depict a cropped, slightly angled view of the front entrance. I didn't need to show everything to tell a story. The diner had big plate glass windows, metal doors, patterned tiles, and brass handrails, all of which created multiple levels of reflection. For me, the drawing was like a big jigsaw puzzle; and when the "pieces" came together, the effect was dazzling.

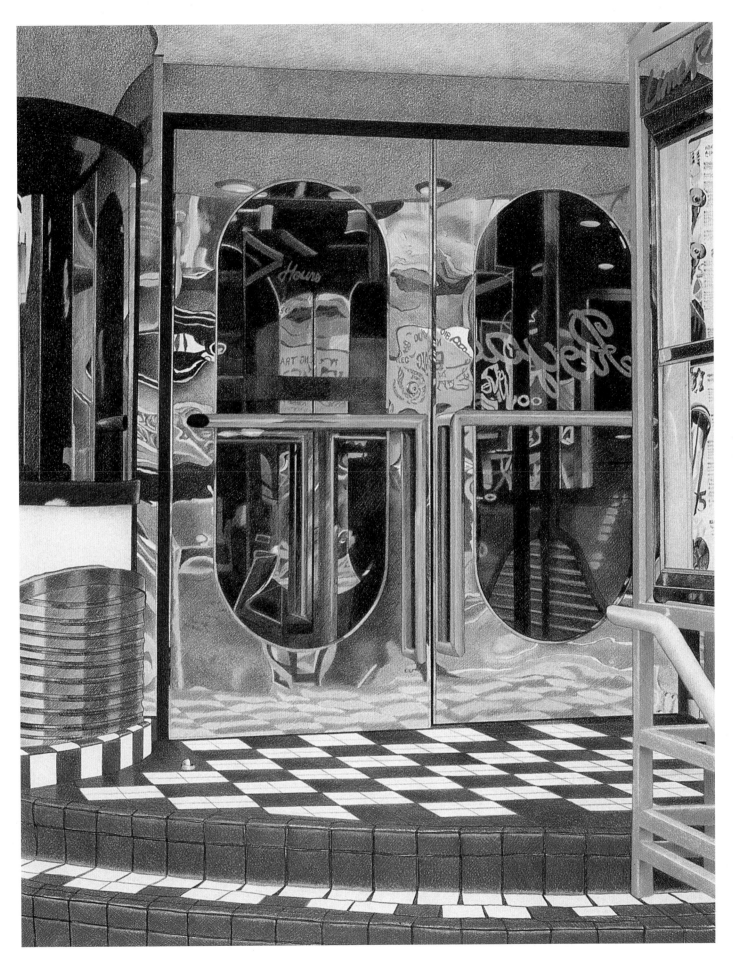

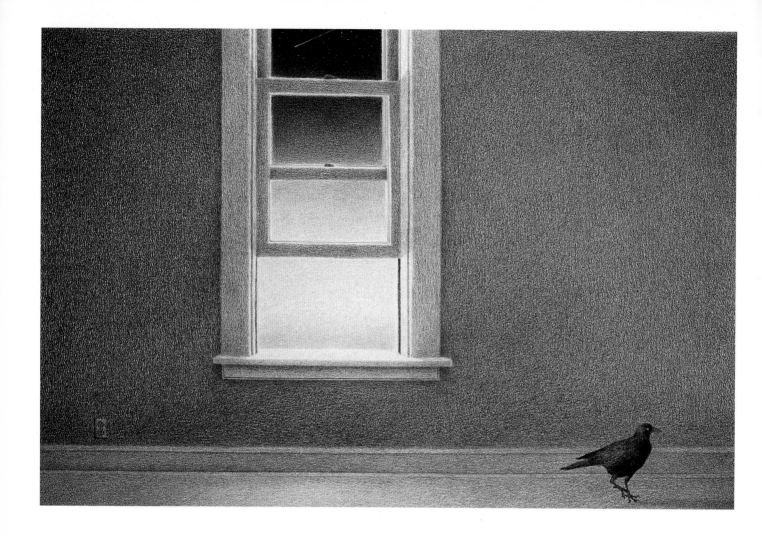

**ALLAN SERVOSS, CPSA**

*Celestial Navigators*

20" x 30" (51 x 76 cm)

Strathmore Heavy Illustration Board, White

*Celestial Navigators* started as a picture in my "mind's eye" of a window and a room. As I laid out the drawing, the room went through various incarnations. The piece evolved slowly, and gave me plenty of time to conceive of possible outcomes. I kept simplifying as I worked. I wanted elegant spaces to surround the window. The crow and the streaking meteor occurred almost simultaneously. The finished piece echoes my concern with space, mood, and simplicity.

**KATHERINE McKAY**

*Dune No. 5*

25" x 19" (64 x 48 cm)

Canson Mi-Tientes, Green

Boulders, trees, and dunes are essentially portraits of natural sculptures molded by wind and water. Energy is manifested in swirling abstract shapes that hold together for a while and then dissolve to make new shapes, equally ephemeral. Shaped by the harsh conditions of their environment, they are worthy of admiration. I drew in front of this dune for several days, dodging little dune buggies and brushing sand out of my sandwich. After watching these vehicles make tracks all over this beautiful landscape, I was glad to be an artist and not a photographer.

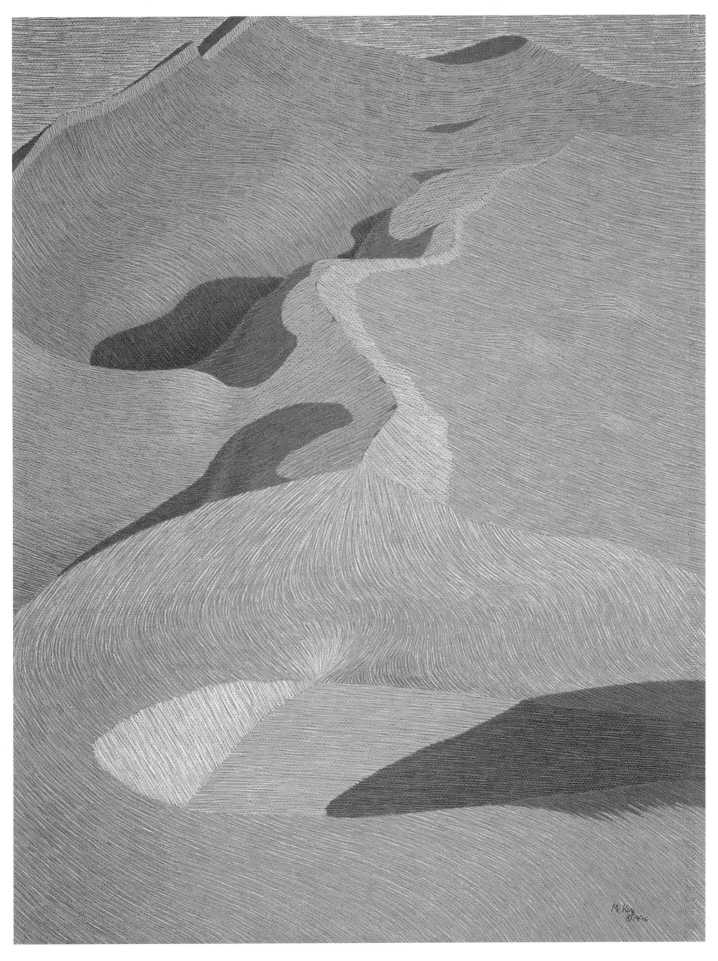

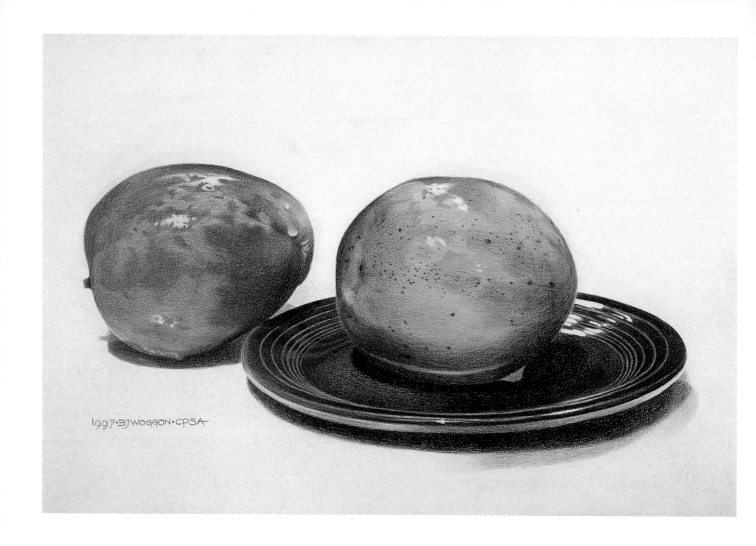

**BRENDA J. WOGGON**

*Primary Food Grouping*

9" x 14" (23 x 36 cm)

Strathmore Bristol Plate Finish, White

This painting is essentially an observation of simple color and form, which allows me to focus on details without becoming overwhelmed by them. This is part of a series of various fruit on blue, Fiesta plates. Each painting is done with a different brand of colored pencil to see if I can still get the same "look" in the finished product.

**SCOTT PAULK**

*Pair of Eights*

19" x 21" (48 x 53 cm)

Strathmore 500 Illustration Board, White

This painting began with my purchase of an H.O.-scale, electric toy train. I was quite taken with the workmanship of this little machine. Since I have an affinity for Western things, I set up the toy train and other objects on a parchment map of the Southwestern United States and Mexico. (The hand of cards was the luck of the draw!) When all of these objects were put together, they symbolized my sentiments about the Southwest. It is a personal painting.

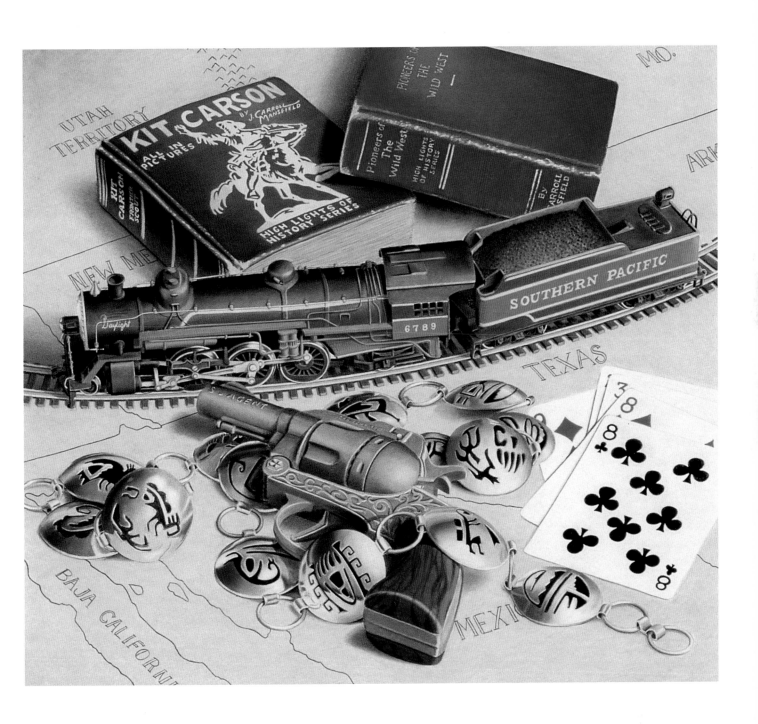

## JILL KLINE, CPSA

*His Gifts of Grace*

11" x 8" (28 x 20 cm)
Canson Mi-Tientes

As I grow older, I feel an urgent need to communicate the similarities that
we all share. If I could, I would go out and offer encouragement to everyone
I met; but with my somewhat clumsy and ineffective personal manner, I can
affect people mostly through my art. An image of blueberries in a dish is
somehow comforting.

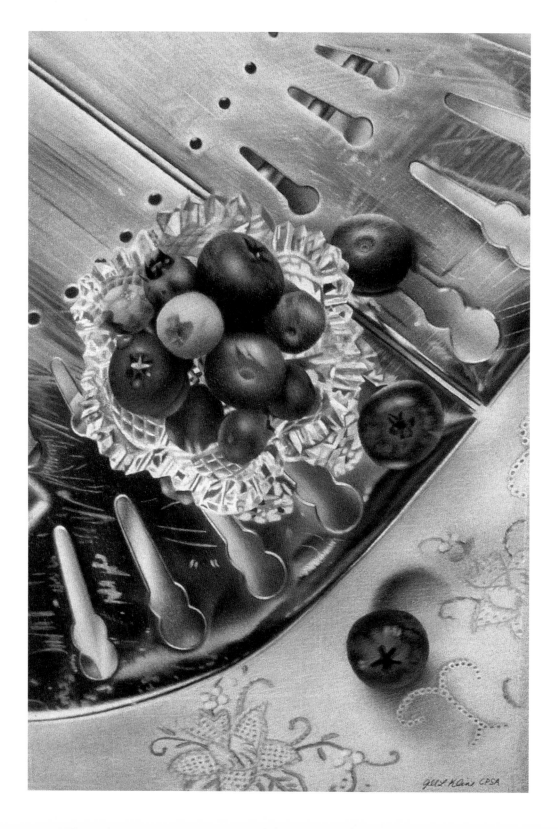

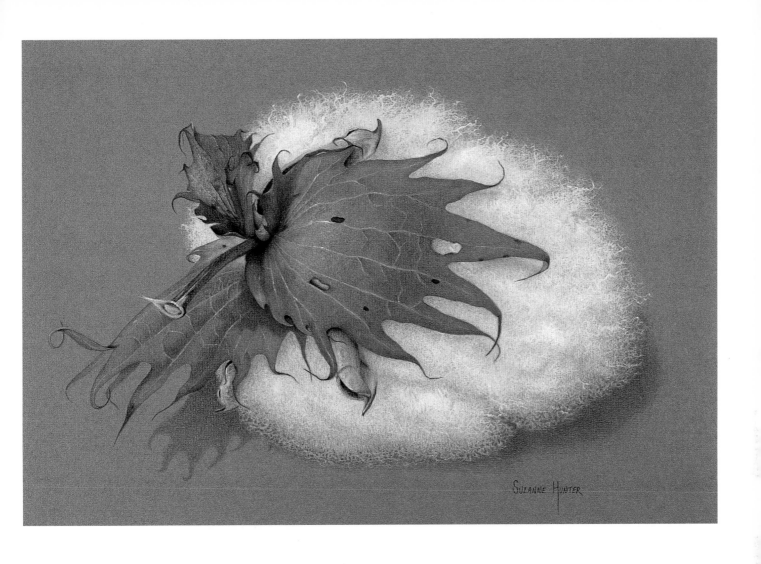

## Suzanne Hunter, CPSA

*King Cotton*

14" x 20" (36 x 51 cm)

UltiMat, Tamarisk Green

Raised in the Rio Grande Valley, I have always been surrounded by fields of cotton and chili peppers. Most people find the vibrant greens and reds of chili to be eye catching. However, I found beauty in the brilliance of the white cotton fiber and the warm color changes in the pod. As I worked on this drawing, I held the boll in my left hand where I could see all the detail that my photo had missed. The cotton boll is such a simple object; and yet, given the opportunity to examine it more closely, I found it had a very intricate design.

37

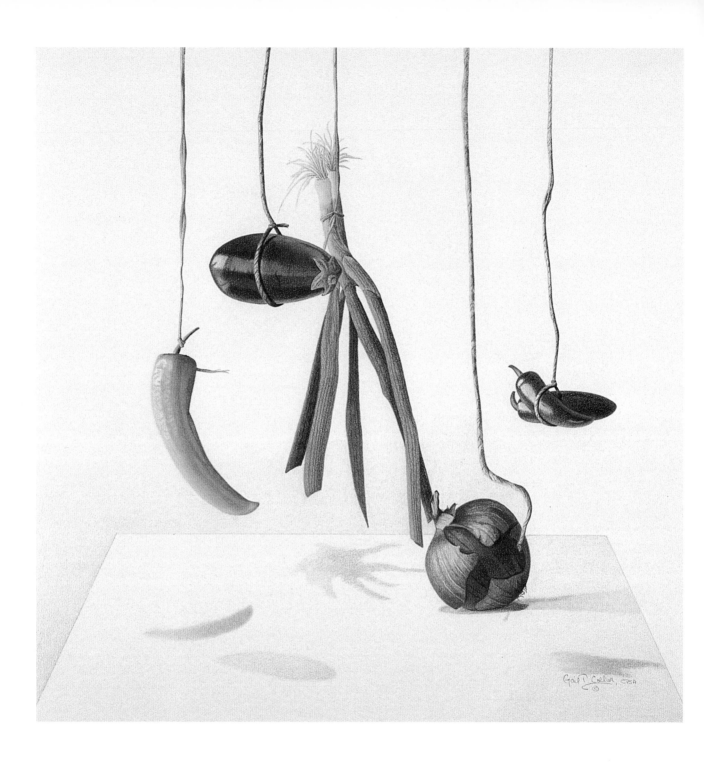

## GAIL T. COLLIER, CPSA

Friends of CPSA Award

*Things on Strings*

18" x 18" (46 x 46 cm)

Rising 2-Ply Museum Board, White

I wanted to create a surrealistic air of mystery to this still life by removing the vegetables from the traditional tabletop and suspending them in the air. I used an ambiguous light source, increased the intensity of the vegetables' colors, and repeated these colors in the cast shadows. The varying heights and intervals of the strings and the vegetables provided an interesting visual rhythm. In this artwork, what at first glance appears very simple, upon reflection is more complex. For me, it's a metaphor for life.

## SHERI LYNN BOYER DOTY, CPSA

*Reflecting*

19" x 14" (48 x 36 cm)

Strathmore 4-Ply Bristol, White

The quote, "necessity is the mother of invention," describes why I work with colored pencils. For a number of years, I worked in a variety of mediums: oil, acrylic, and chalk, among others. But, there came a time when I had no studio in which to paint and an infant son to support. I used graphite pencils to do commissioned portraits but had a desperate desire to work with color again. I have since used colored pencils in the same way I have always painted with oil. While I still work in much the same way as I did 20 years ago, it is with a greater freedom of expression. Colored pencils are as much a part of my art as the hand I use to do the work.

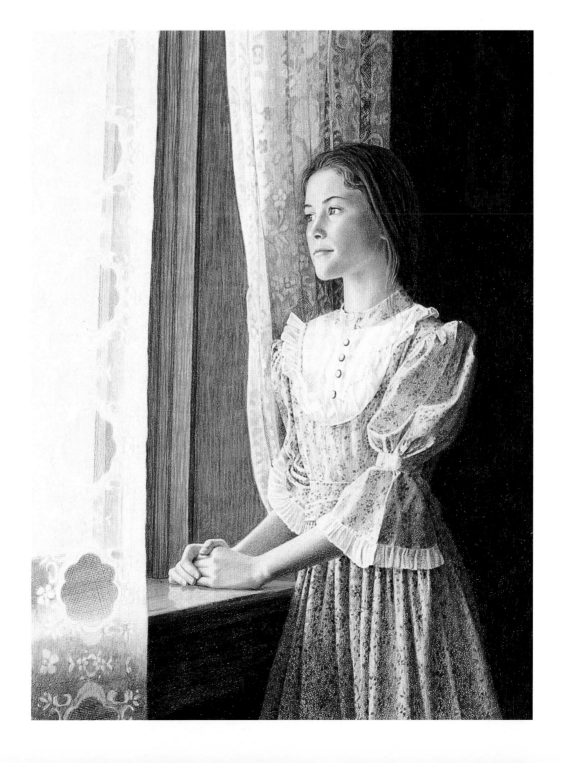

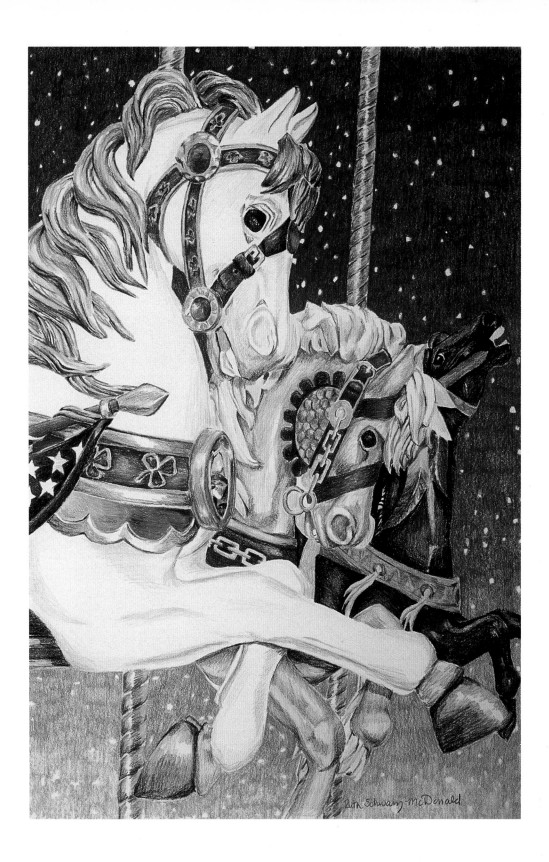

**RUTH SCHWARZ McDONALD**

*And The Winner Is...*

24" x 19" (61 x 48 cm)

Strathmore 140 lb. Hot Press Watercolor, White

What keeps me working? It's the idea that I can take a flat piece of white paper and transform it into an illusionistic image. Instead of keeping the horses on the carousel, I wanted them to appear as if they were flying. In this way, you can imagine that anyone of them could be the winner!

# JAMES K. MATEER, CPSA

*Vintage Nova*

33" x 20" (84 x 51 cm)
Pyro Mat Board, Brown

The creative process that I utilize in my work is one of discovery, exploration, development, and production. So, I spend a great deal of time driving around Northern Ohio, looking for subject matter that might be appropriate for my work. Compositionally, I believe in the concept of what I call "jamming the space." Since my subject matter was this rickety, dilapidated railroad tower, I filled the entire paper with it. Additional material was included only when it enhanced the composition.

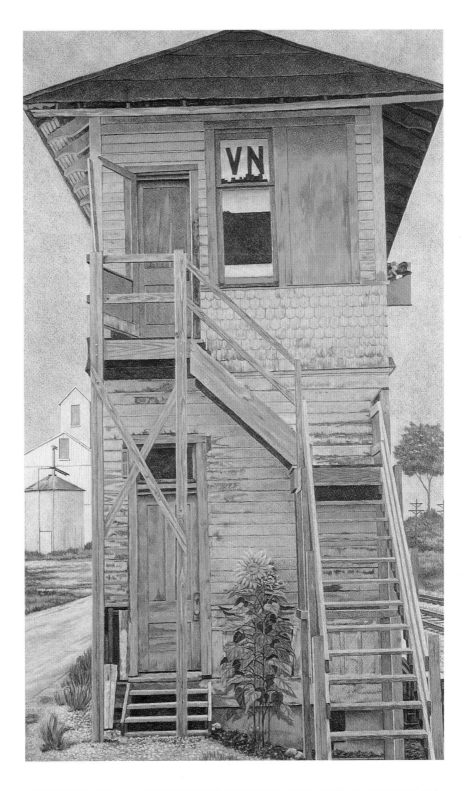

## SHEILA SCANNELLI

*Beyond The Locked Door*

29" x 23" (74 x 58 cm)

Crescent Mat Board, Light Umpria

While taking photographs in a flower garden, I noticed the door of an old
building near by. Hanging off the door's hasp was a huge padlock. The variety
of textures—from painted wood grains, rusty and shiny metals to the coarse
bricks and reflective steel—created an interplay of strong light and shadows.
I wanted go inside and explore what was beyond that locked door. It made
me feel like Alice in Wonderland searching for the white rabbit. Since it was
the lock that first intrigued me, I decided to keep the composition personal
by isolating this focal point from its surroundings.

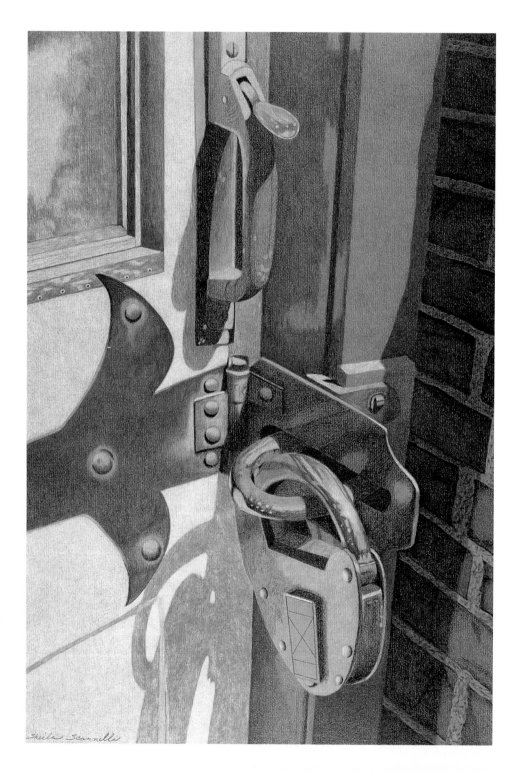

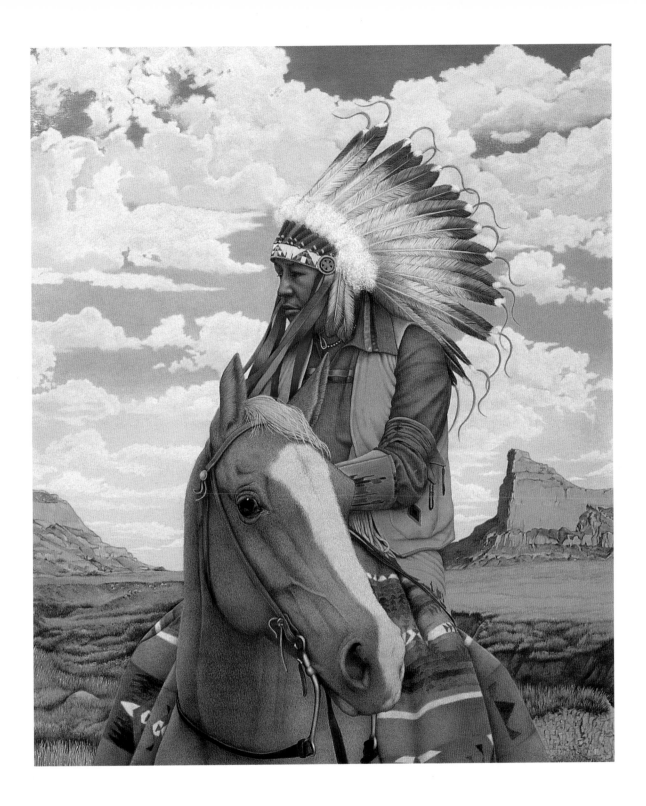

**STAN PAWELCZYK**

*Me-A-Pa-Te*

22" x 18" (56 x 46 cm)

Mylar

If I had to choose a time in American History in which to go back, it would be when Lewis & Clark explored the American West. For many years, I have attended Native American pow-wows from coast to coast, visited numerous museums and libraries, and have accumulated an extensive library of books and reference materials. This painting is one of my favorites. The title, "ME-A-PA-TE" means "My Ancestors Hunting Grounds" and seems to reflect in the subject's sad but proud face.

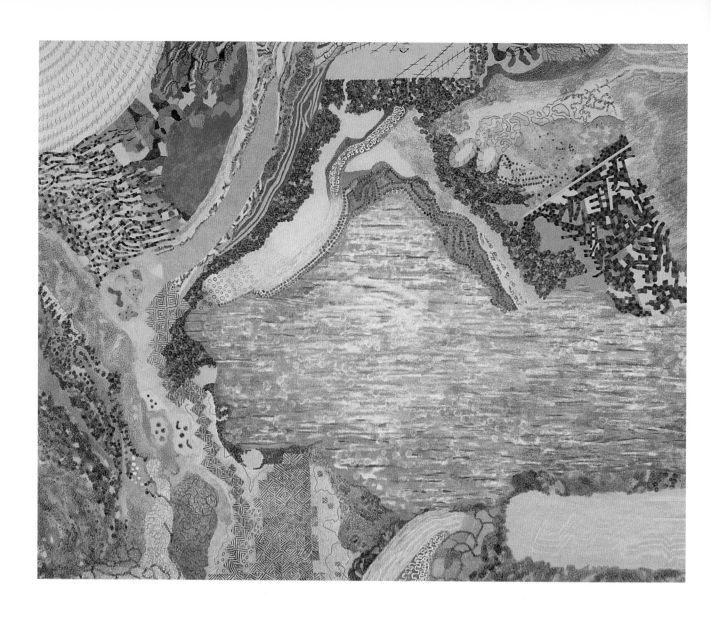

SABYNA STERRETT

*Flying Home Again*

17" x 21" (43 x 53 cm)

Crescent 4-Ply Mat Board, Palm Beach

This work was the tenth in a series of aerial views of Mississippi. It is about
the spiritual, emotional, and visual ties I associate with a sense of place. I
seldom work from the photos I take but work abstractly in a sort of meditative
state to let the things I want to say visually be my guide. I hope to evoke a
sense of reflection, movement, time, and space using many elements of the

southern landscape.

**DONNA BASILE, CPSA**

CPSA Award for Exceptional Merit

*Rock-A-Bye-Baby*

38" x 32" (97 x 81 cm)

Stonehenge Paper, White

My colored pencil drawings are often mistaken for oil paintings. This large-scale work was accomplished with numerous layers of non-directional, cross-hatched strokes applied until the white of the paper is covered. It took three months to complete. Working free-hand, I analyzed the subject and made imaginary proportional lines and perceptual measurements, comparing one object to another and checking measurements to establish the relationships between them. I only use photographs for reference guides and do not to use projectors or grids. I am a realist, not a photorealist.

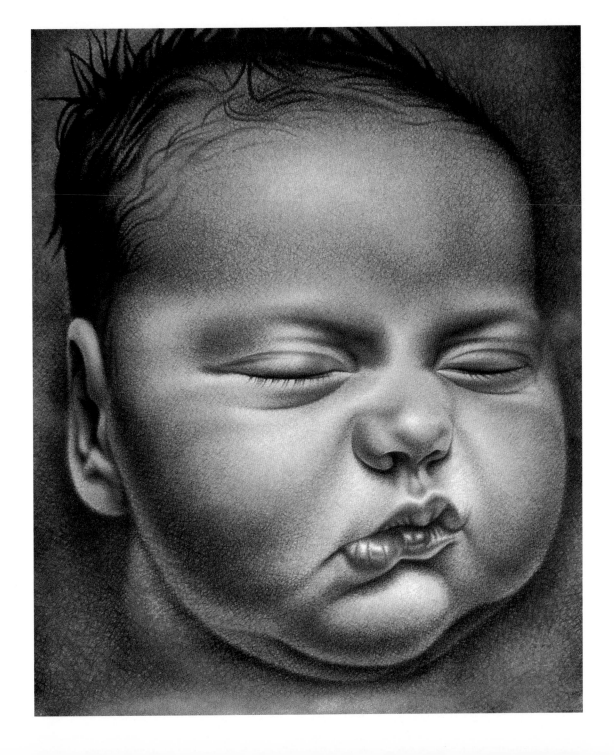

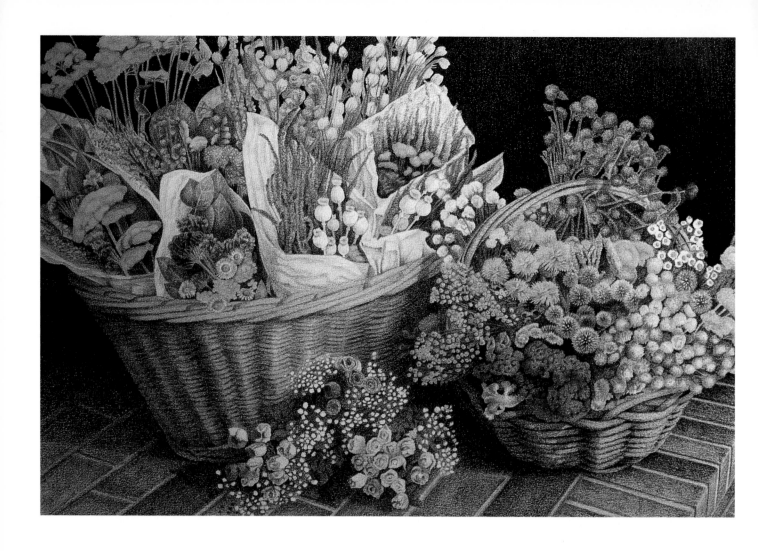

**CATHY HELLER**

*Everlastings*

17" x 24" (43 x 61 cm)

Strathmore 3-Ply Bristol 500, White

I call my sister Janice the "flower lady." She grows them everywhere, dries them, and sends me boxes of them. I wanted to preserve the passion and fun my sister and I share for these flowers and to capture the special bond between us. Compositionally, this artwork is 90% stippling—tiny dots created with a pounding motion with colored pencils. It's a long and tedious process. After five or six layers, I realized I would never get the depth I wanted using just this technique, so I blended longer strokes over the stippling. This helped me complete the work within this century.

**DENISE DANIELSSON**

*Botany/Virology*

15" x 24" (38 x 61 cm)

Canson Mi-Tientes, Lily

Although my work may initially look simple, upon closer examination, it is more complex: the two dimensional can appear three-dimensional, the figure/ground reversal becomes evident, the treatment of pattern is more kinetic than it is static, and the image's color verges on the surreal. With a formal education as an artist and designer, I was trained as a repeat-pattern designer. Pattern is everywhere, especially in nature. Unlike the physiological reasons on which pattern in nature is based, patterns in my drawings evolve spontaneously.

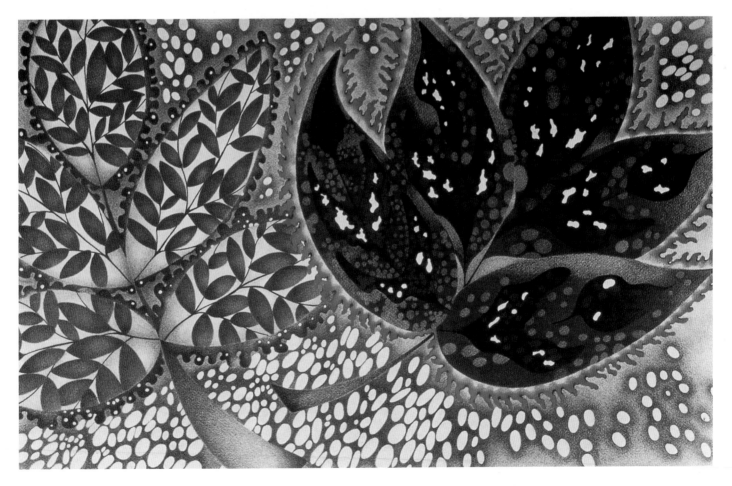

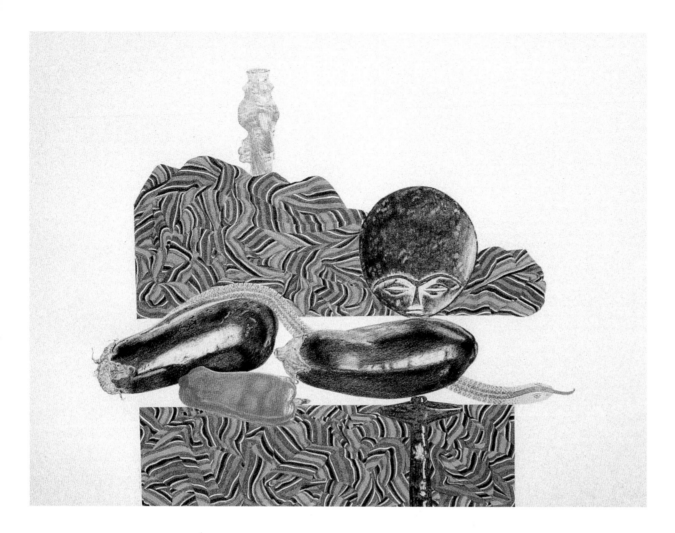

**DONNA LEAVITT**

*Garden Of Eden II*

24" x 29" (61 x 74 cm)

Arches Aquarelle 2-Ply Hot Press, White

For a long time I worked in only black-and-white media—printmaking and graphite. After a trip to Central America in the late 70's—with all that color dancing in my head—I began incorporating colored pencil with graphite. I continue to use both these mediums today, together and separately. *Garden of Eden II* evolved from various fertility artifacts that I have around my house. The striped fabric not only embellishes the design but also is a strong visual tool that entangles the viewer and invites greater inspection. This is important to me because art must earn more than a casual glance.

**JENNIFER PHILLIPS WEBSTER, CPSA**

*Highs in the Low– to Mid-Thirties*

18" x 12" (46 x 30 cm)

Strathmore 4-Ply Illustration Board, White

I photographed this clump of ice that had formed outside my kitchen window. Its simplicity intrigued me; its intricacy challenged me. (And had I cleaned out my gutters regularly, I would not have been afforded this spectacle!) At first I felt committed to my photograph, but eventually became frustrated by its limitations. As the drawing progressed, accidents happened. It was at this point that I eagerly opened myself to new possibilities and experienced a freedom of expression and absence of inhibition.

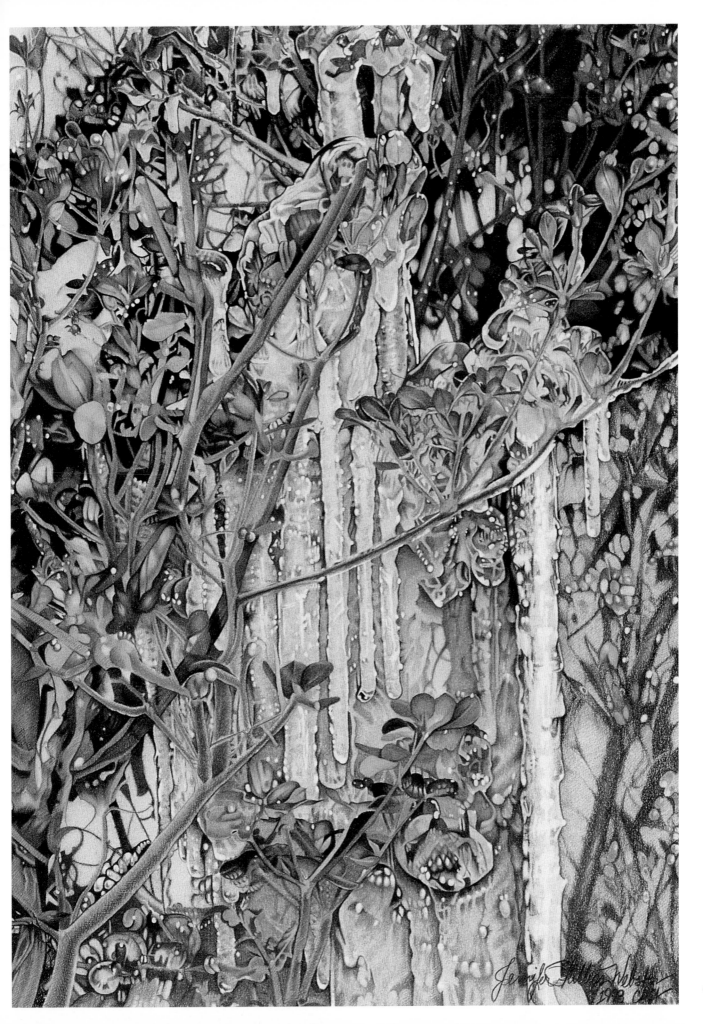

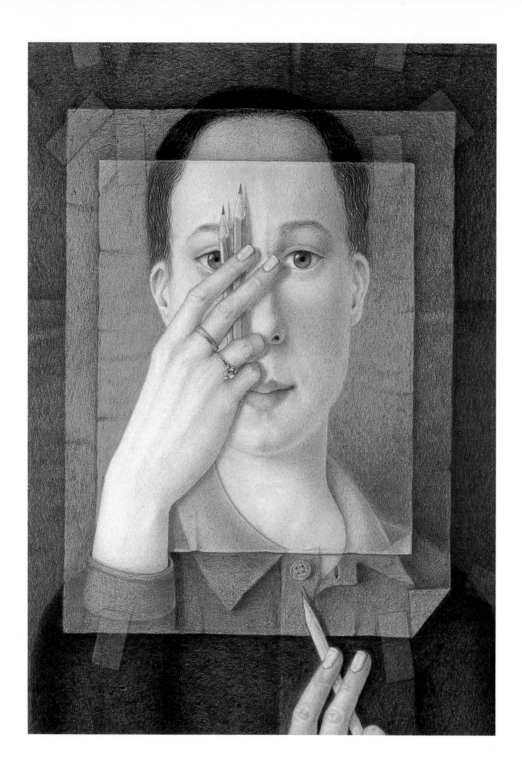

## MONIQUE PASSICOT

Friends of CPSA Award

*And So Forth*

18" x 13" (46 x 33 cm)

D'Arches 300 Hot Pressed, White

It's difficult to explain how this painting came about, because it practically painted itself: A line became the outline of a hand. The hand painted the face. The face then asked for the division of the paper into fragmented parts, and the outer sheet demanded the other hand in order to become believable. This is typical of the way I work. I seldom start with a sketch. I trust my instinct and enjoy the discovery. My work is never about definitions or reaching a final meaning. All it offers is a certain way of looking at things.

## CAROL J. JOUMAA

*The Meadow*

15" x 11" (38 x 28 cm)
Crescent Hot Pressed Illustration Board, White

I am more comfortable in the fantasy world. It is there that I am able to create what I want. The real world has too many restrictions. In the fantasy world, I am in control, making of it anything I wish.

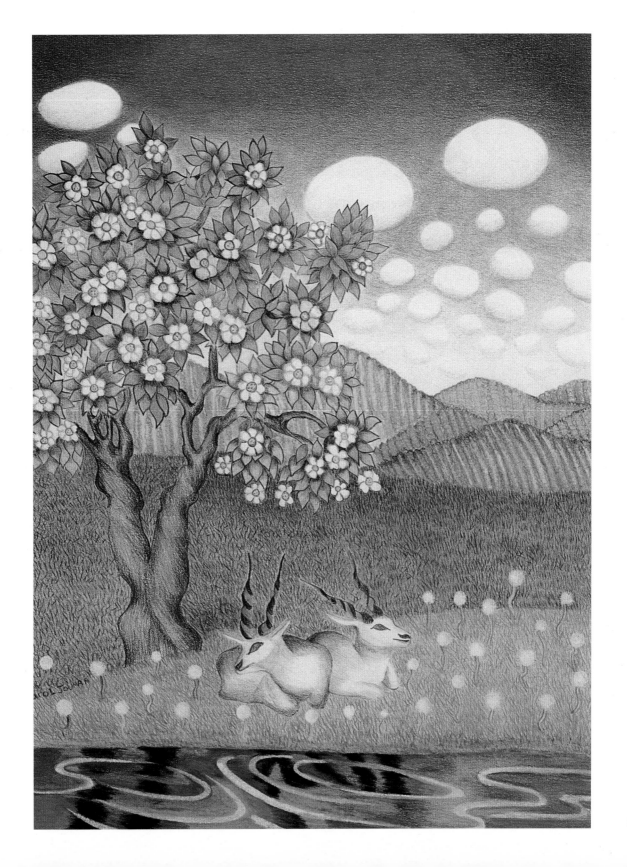

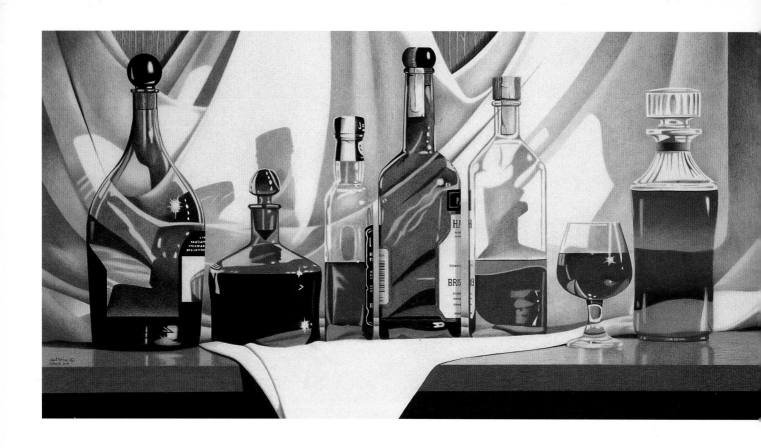

**ROBERT GUTHRIE, CPSA**

*Happy Hour*

14" x 28" (36 x 71 cm)

Mylar Transparent Film

*Happy Hour* was done on transparent Mylar film. I began by creating a value study on the backside of the Mylar with cool and warm gray pencils. Once the values were defined, I turned the sheet over and applied the colors until they completely saturated the front side. And I had fun doing this piece. Some artists talk about all of the hard work they do; I can't understand them. Hard work is spending long hours doing something you dislike. Creating art gives me great pleasure, and I never get tired of it. I hope these feelings show in my work.

## JANE WIKSTRAND, CPSA

*Browsing At Seret & Sons*

20" x 25" (51 x 64 cm)
Strathmore 4-Ply 500, White

We discovered this amazing shop of old collectible, Middle- and Far-Eastern imports. What a visual treat! Despite lots of clutter, patterns, textures, and shapes, this particular row of jars against the weathered doors was a perfect subject. However, what often works in a photograph doesn't always transfer onto paper. I approached this painting as a jigsaw puzzle, only in reverse. I selected the best angles to photograph and then adjusted the colors and values, using the white of the paper to create a stronger contrast. I chose this composition by moving things around to enhance the composition without disturbing the reality.

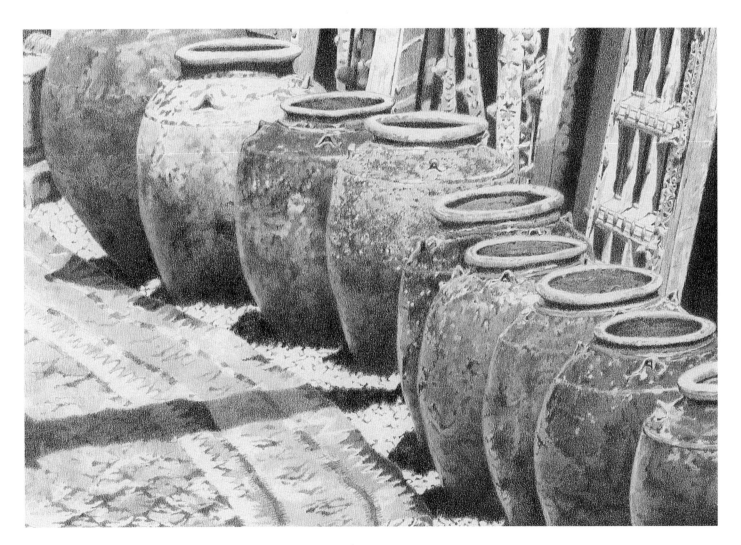

**SUZANNE M. BAUMAN**

*Back To Nature*

28" x 31" (71 x 79 cm)
Windberg Art Panel, White

Early in my career I wanted to duplicate on paper what I saw with my eyes. Now I want to express on paper what exists, but what my eyes do not see. I love to experiment, especially when I'm told that it "can't be done." In this work, I applied a variety of strokes using pencils, art sticks, mineral spirits, sgraffito, burnishing, and pressed leaves for stencils. At first, this abstract piece began to look technical, mathematical. I then decided branches, roots, leaves, and berries would make good contrasting elements. You have to look closely to see what is contained, expressed, and hinted at within my complex, colorful design—from organic shapes to a push pin.

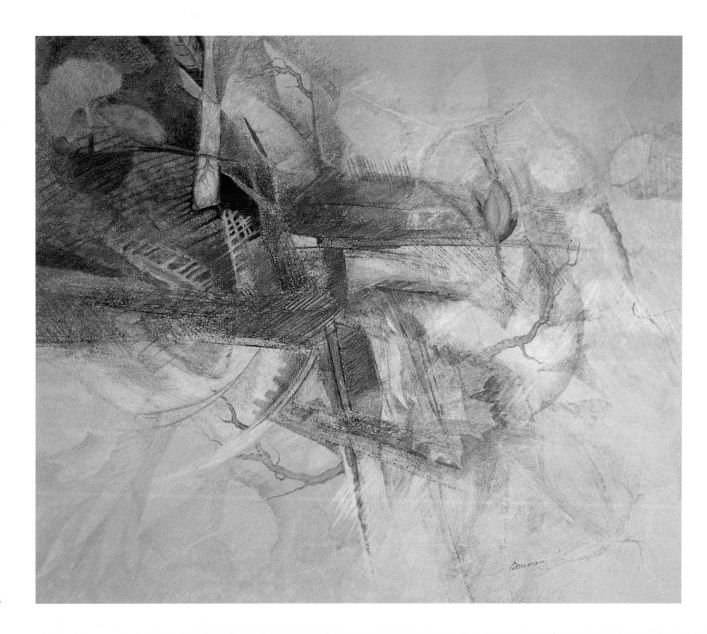

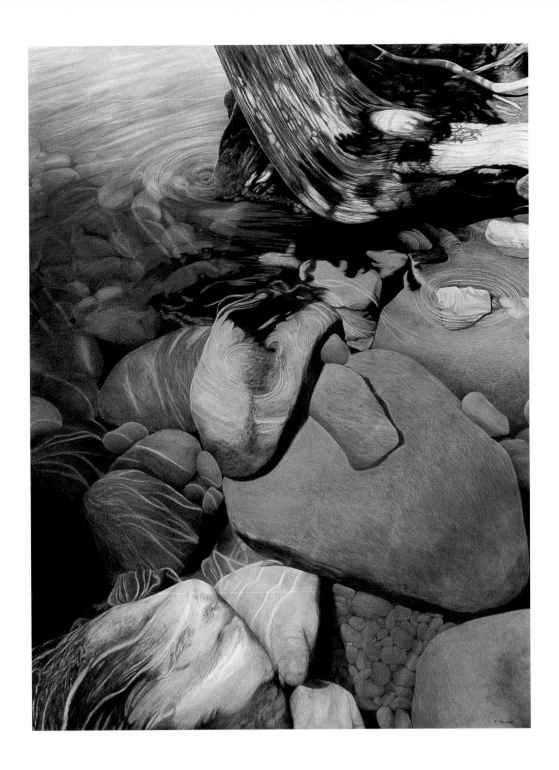

**ELIZABETH HOLSTER, CPSA**

*Isle Royale Portage*

25" x 19" (64 x 48 cm)

Strathmore 500 Bristol Plate, White

A few years ago, I was selected to be an artist-in-residence on Isle Royale, a National Park consisting of a remote ridge of islands near the Canadian shore of Lake Superior and home to moose, wolves, birds, fox, and a host of other creatures. I was given a primitive cabin and a canoe during my stay to create work that captured the spirit of the area. Without electricity, I did not have adequate light to actually complete any works, but I did make entries in my journal/sketchbook. I was also able to take hundreds of photographs within a full range of weather conditions and lighting variations. The intimacy and physicality of the setting were special points I wanted to express in my work.

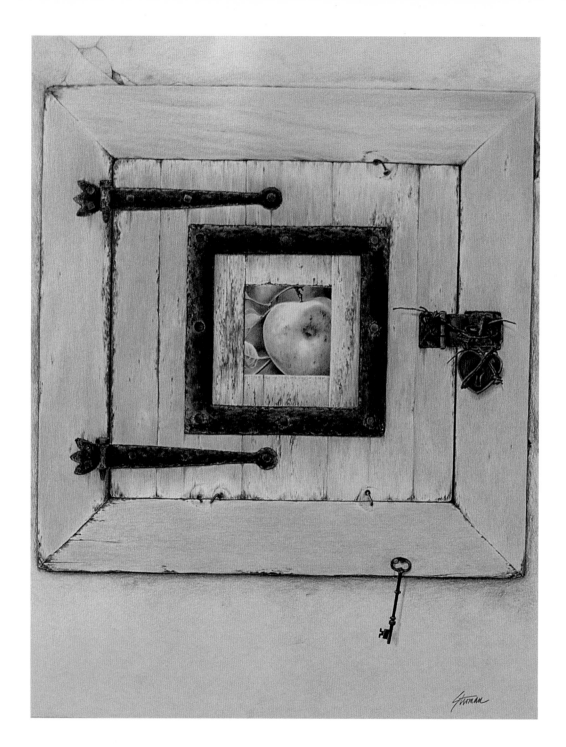

**BRAD STROMAN**

*Forbidden Fruit*

24" x 19" (61 x 48 cm)

Strathmore 300 Bristol, White

Up to this point in my career, I was a recorder of the world around me.
To accomplish this new work, I wanted to strike a sensitive balance between
merely recording recognizable surfaces and creating a thought-provoking
visual statement on mankind. I designed the composition so that the
unattainable fruit is framed in a contrived yet believable window. Weathered
with age, it still remains closed and secure. The heart-shaped lock, rusted
shut, is entwined with a menacing strand of barbed wire. The key hangs
unused from the window frame. Even if you were able to squeeze your hand
through the tiny opening and pluck the apple from its stem, it would be
impossible to retrieve the prize once in your grasp.

**JEANNE TENNENT, CPSA**

*Contours*

26" x 28" (66 x 71 cm)

Crescent 100% Rag Board, Light Gray

My studio is filled with bits and pieces of nature—rocks, wood, leaves, and other items. My fascination with the reef stones, water-pool stones, coastal stones, and mountain rocks are the inspiration for this work. I have had meditative thoughts about the earth, and the oceans, shores, graves, Indian mounds, and settler fences. Who moved these rocks and when? Who will move them again and why? I feel as though these rocks will be here through time, never aging.

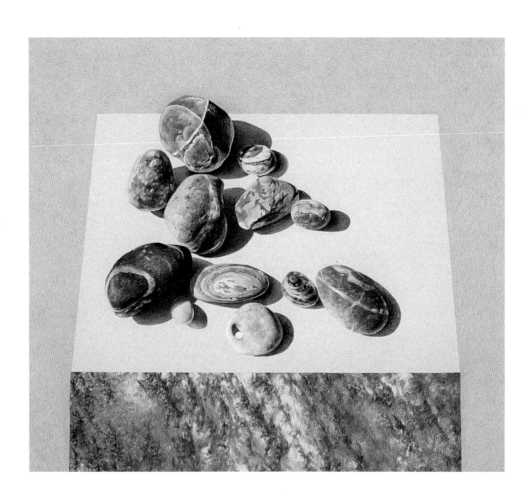

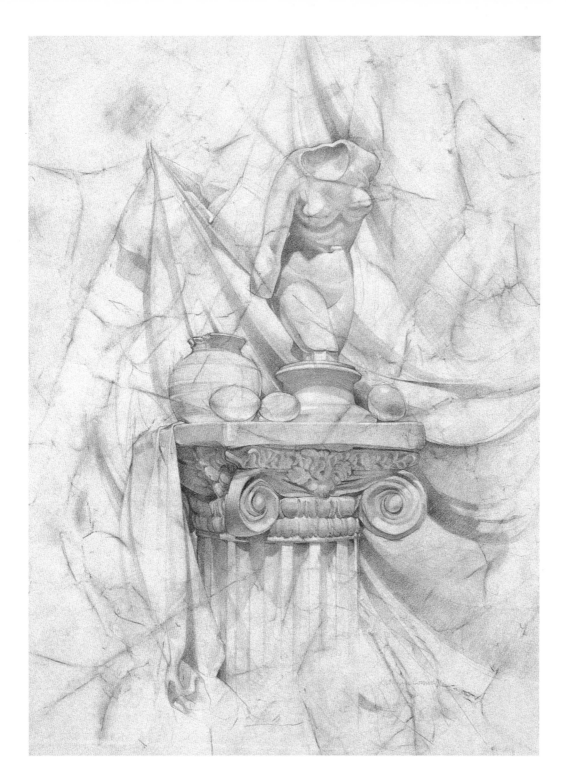

**KATHRYN CONWELL**

*Classical Harmony*

30" x 22" (76 x 56 cm)

BFK Rives Printmaking Paper, White

Recently, while working in a classical manner using Conté crayon on paper casts, I thought, "Why couldn't I use this same technique with colored pencil and a solvent?" So, I laid my drawing paper on the sidewalk and poured mineral spirits over it. Then I crinkled up the paper and rubbed art sticks over the edges of the wrinkles. Once dry, I flattened the paper through a press. The creases do not come out completely, but that is the beauty of it. Being partial to line work in art, this technique allowed my lines of construction to remain obvious.

**PENNYE L. HANKY**

*Rhubarb Rabbit*

22" x 17" (56 x 43 cm)
Canson Mi-Tientes, Light Blue

To make this illustration, I was inspired by a small picture of gorgeous rhubarb leaves on a seed catalog. It brought back memories of eating my grandmother's rhubarb pie as a child and watching bunnies hop through the yard. My work is about moments—those gentle, peaceful, childlike moments that surround us everyday. Moments that are missed as we speed through life.

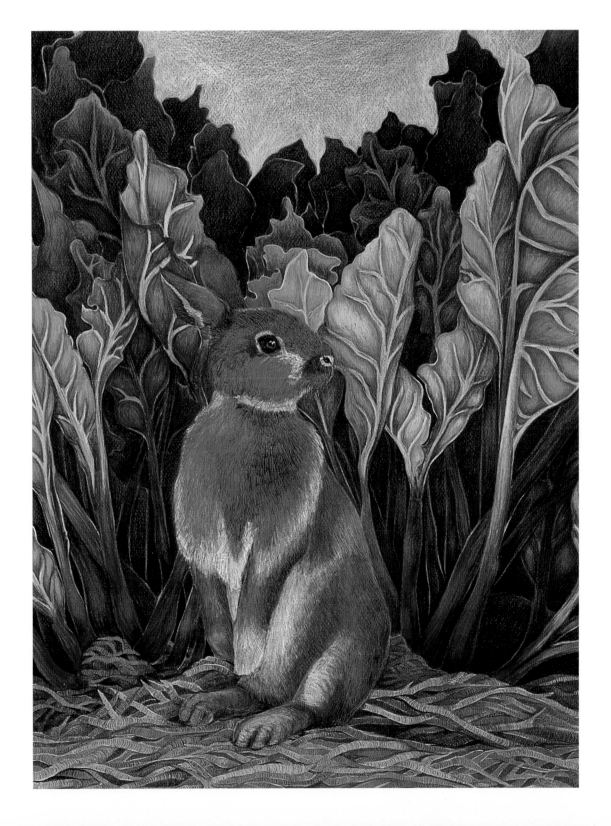

## KRISTY A. KUTCH

*Angelique Tulips*

18" x 12" (46 x 30 cm)

Rising 4-Ply Museum Board, White

I was inspired to render these unusual Angelique tulips because they are hybrids and look just like peonies. Since I often spend months on one colored pencil painting (I never claimed to be prolific!), I will only undertake a subject that I thoroughly enjoy. Life is too short to spend that kind of time on something that doesn't automatically pull me back to the drawing table.

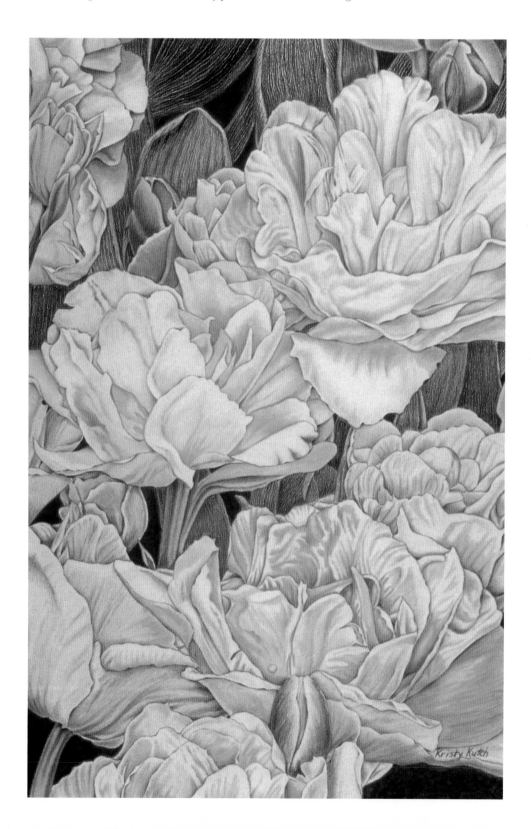

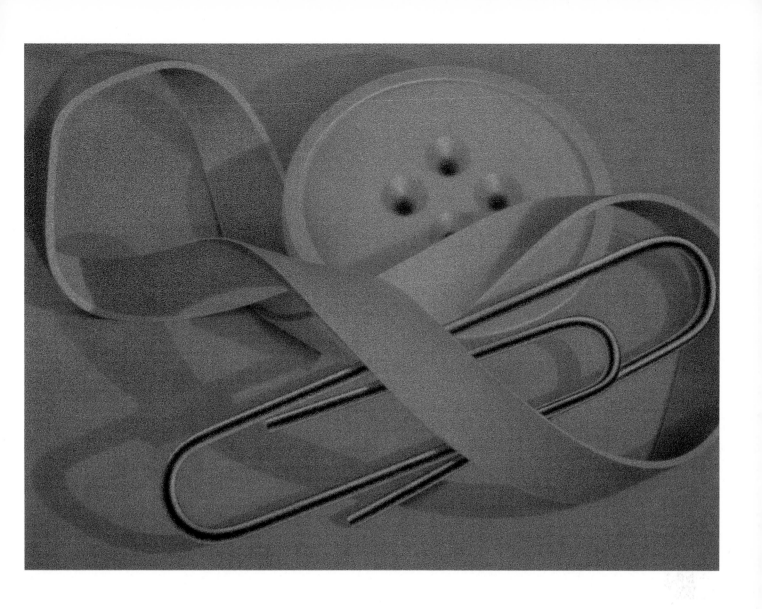

**CONSTANCE MOORE SIMON**

*Still Life With Paper Clip*

9" x 13" (23 x 33 cm)

Strathmore 500 2-Ply Bristol, White

Although my work is representational, I think like a non-objective artist.
I challenge myself to orchestrate visual elements into an emotionally mean-
ingful whole. Organizing shapes, space, line, light, and color have exciting
potential for personal expression. I am motivated by this process and am
certain that I will spend the rest of my days arranging and rearranging small
objects so I can create my "organized visuals." There is no political, symbolic,
narrative, or sentimental meaning to my choice of subject matter. I am
simply celebrating the ordinary.

**EDNA L. HENRY, CPSA**

*Le Julyann*

15" x 16" (38 x 41 cm)

Rising 4-Ply Museum Board, Black

This drawing began in Paris in a small cafe across the street from Le Julyann. As I sat at my table, I saw an ordinary street corner become transformed by the coming darkness and gradual appearance of lights. Who were these people? What brought them together at this time and place? When my desire to capture this scene finally overcame my reluctance to look like the ultimate tourist, I took out my camera, as inconspicuously as possible, and snapped two very quick shots. I wanted to capture something of the mystery and mood of that cold March evening.

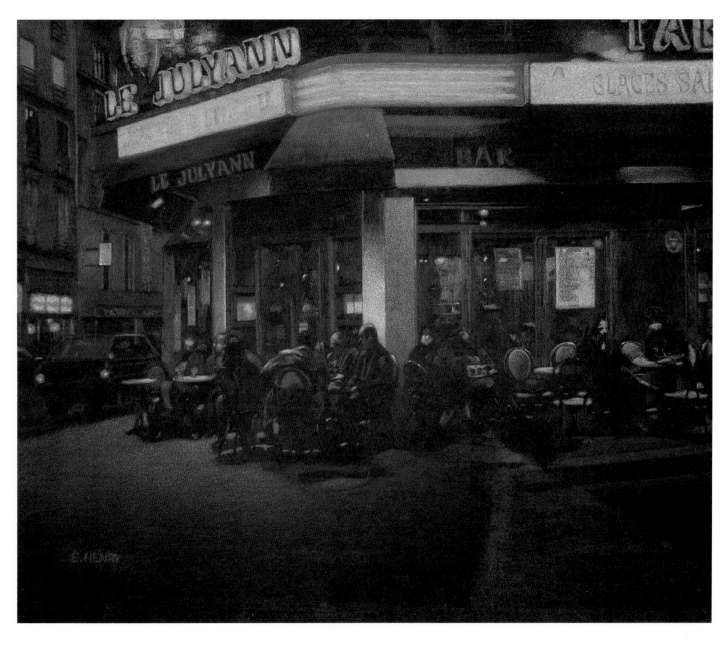

### RICHARD QUIGLEY

*Approaching Storm*

20" x 24" (51 x 61 cm)

4-Ply Bristol Plate, White

Imagination is the most important element in my drawings. My references come from drawing journals, photographs, and artifacts acquired during my extensive travels to ancient archeological sites around the world. In other words, if I haven't been there or seen it with my own eyes, I won't paint it. The figures in my work are slightly abstract. I also include depictions of the oceans to illuminate mankind's relationship with them. In "Approaching Storm," does man overpower nature or does nature control man? My art is about my adventures, and my adventures are about my art.

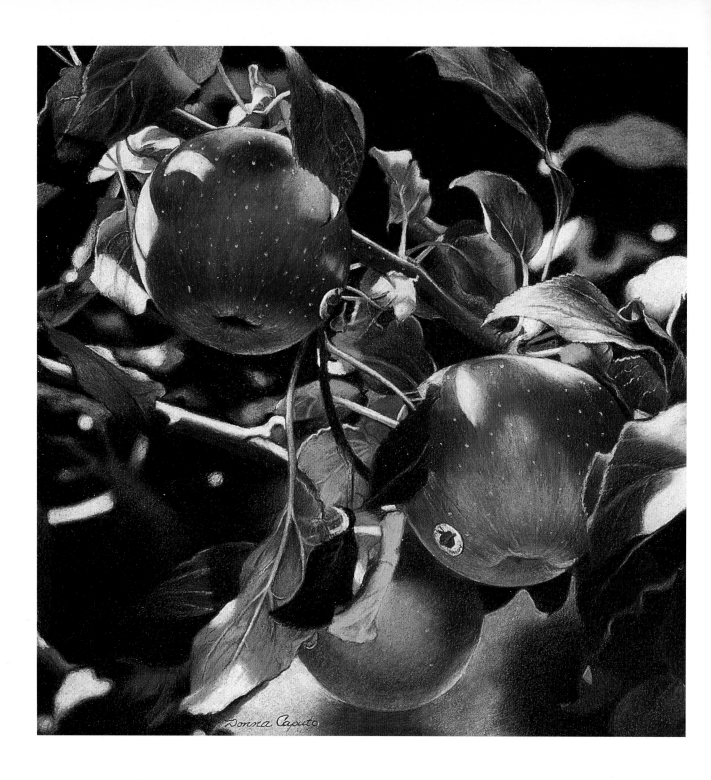

**DONNA CAPUTO**

*Seal Of Approval*

10" x 10" (25 x 25 cm)

Windberg Pastel Paper, Sage Green

Ever conscious of taking myself too seriously, I continuously look for a way to inject humor, mystery, uncommon beauty, or a mood into my work. I used a new painting surface to do these apples, and was merrily going along layering one layer over another, when my sense of humor took over. I could visualize those apples hanging from the tree with their seals proudly displayed on their gleaming skins. I feel that a successful work of art should have artistry, dynamics, accuracy, and, most importantly, poetry.

## CONNIE NEYLAN

*Silent Gaze*

12" x 20" (30 x 51 cm)

Fine Croquille Board, #3

I didn't have much experience with drawing animals. So, when a client commissioned me to do *Silent Gaze* from a photo he had taken, I looked forward to the opportunity. I'm an artist because art challenges me, like a mystery motivates a detective. I love plotting and planning my idea in my mind, getting my information or resources to create a composition, then watching the process grow. The next challenge is figuring out how to manipulate my colored pencils and other tools to produce the look I want. From beginning to end, it's pure problem solving.

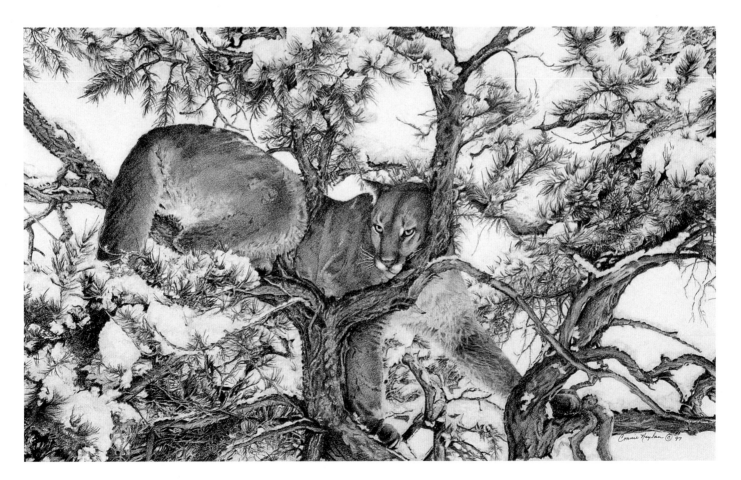

## JANIE GILDOW, CPSA

*Pearfection*

12" x 16" (30 x 41 cm)

Fabriano Uno 140 lb. Hot Press, White

My work is very straightforward. It is a reflection of my personal philosophy along with my ability to render objects and to create the illusion of realism. It requires a great deal of patience and attention to detail. I work slowly and carefully, taking as long as 100 hours to complete a major piece. I believe art should be an invitation—an invitation to enter the work and become lost in it for a period of time, experiencing a heightened feeling of pleasure, a sense of wonder, and a special feeling of personal discovery that can be carried away, remembered, and treasured.

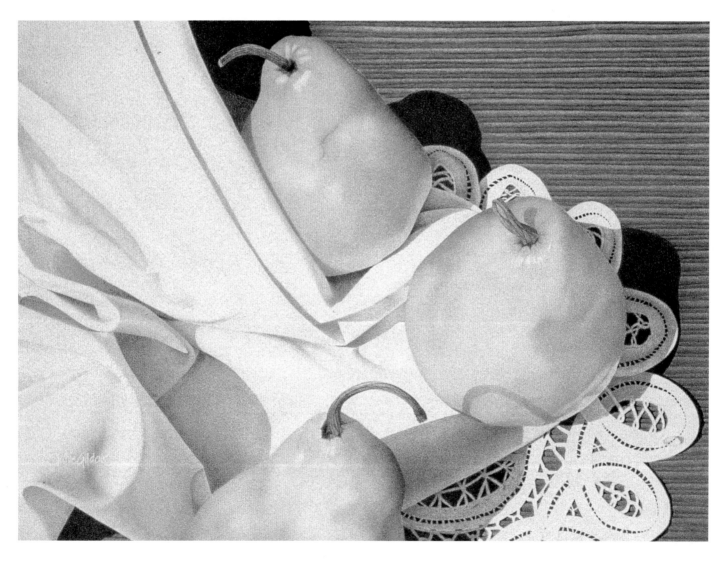

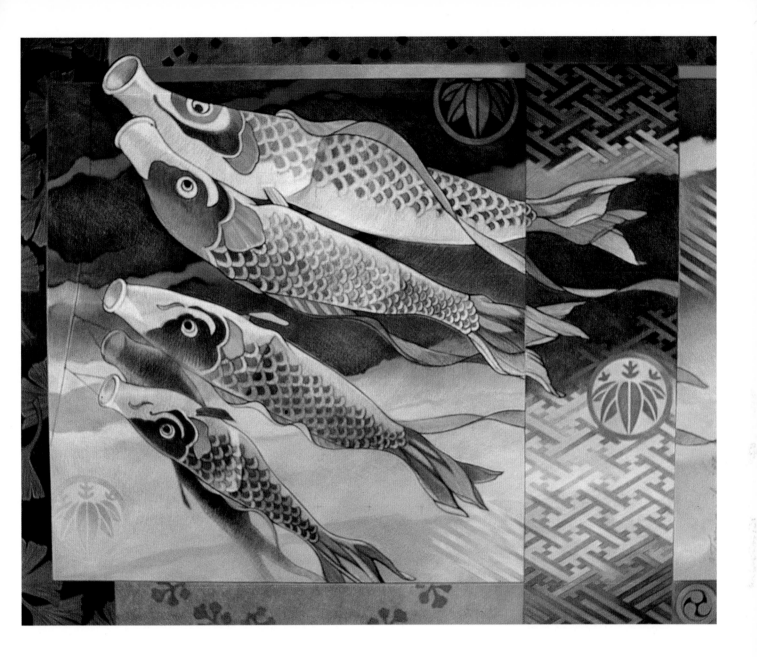

### CAROL TOMASIK, CPSA

*Flying Fish*

31" x 37" (79 x 94 cm)

Crescent Mat Board, Warm Gray

I began *Flying Fish* nearly in the center of a large board and worked outwards in all directions. I soon reached a point where I began to think the drawing was beginning to look too busy, with too many patterns; so I added solid-color bands. I then changed my mind and added yet more patterns, but using only a limited amount of colors. I want viewers to go over every part of the drawing, because not one-square inch was neglected.

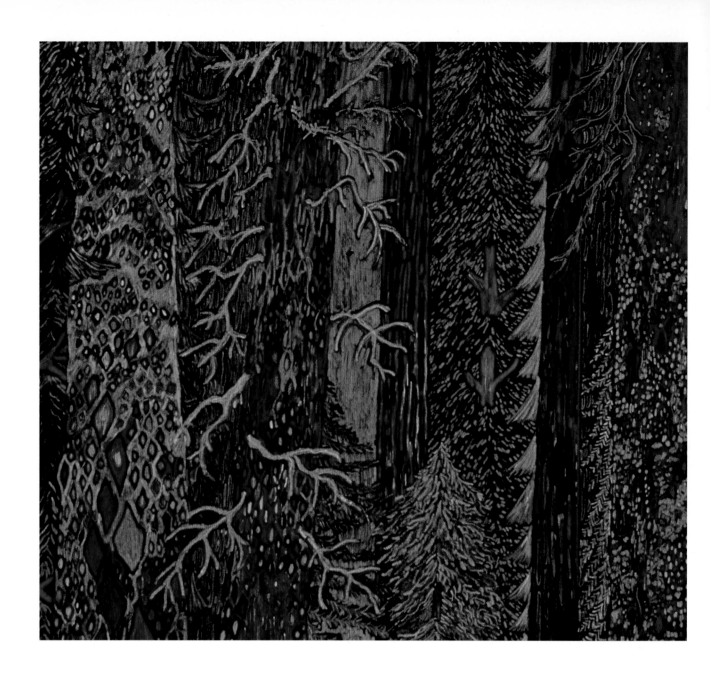

**KATHLEEN FLANNIGAN**

*Old Growth Forest*

24" x 27" (61 x 69 cm)

Fabriano Murillo, Black

Since birth, I have had an obscure neurological disorder that characterizes itself in spasticity, mobility problems, and muscle weakness. I transcend my disability through the freedom to create. My work speaks of a secret language, a strange language. Spontaneous, alive, a moment of beauty, a revelation of innocence—these attributes characterize my work. Elaborate and dense, this particular work consists of a central image of an animal surrounded by highly decorative borders and environments. I try to place my viewers and myself into this decorative world.

**TERESA L. RAMIREZ**

*Domestic Implications*

23" x 24" (58 x 61 cm)

Strathmore 3-Ply Bristol, White

The idea for this illustration came from a body of work investigating interior spaces that depict personal fantasy and the symbolism of objects within them. I created the illusion of slightly distorted three-dimensional reality with an exaggerated two-point perspective. Using a full spectrum of colors, using many tints, shades, tones, and pure pigments, I gave the illusionary depth to some forms that jumped forward while others receded. The woman in this work has abandoned the living area and retreated out of sight of the viewer, leaving behind the images that reflect the duties of a home-bound woman.

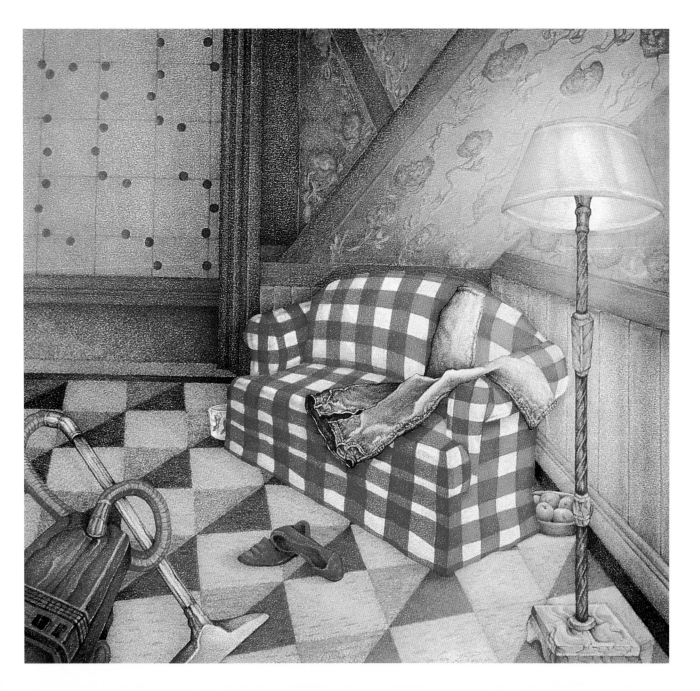

## B.J. POWER

*Muddy Water Reflections*

25" x 21" (64 x 53 cm)

Strathmore Arthgain, Flannel White

My husband and I live on a ranch in southeast Arizona, where all types of animals are very much a part of our lives, especially the cattle. Early one morning, I saw one of our cows standing in a pond of muddy water by the road. The way the morning light reflected on her and how she reflected in the muddy water was just one of those special moments that I wanted to make into a great picture. Fortunately, I had my camera with me, and the cow patiently stood looking at me as I took her picture. The light, colors, and subject all made a statement of our life and the beauty of God's world in which we live.

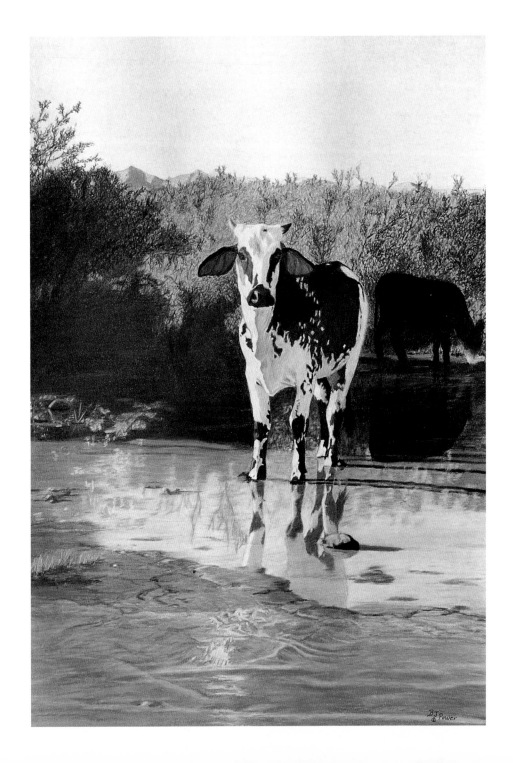

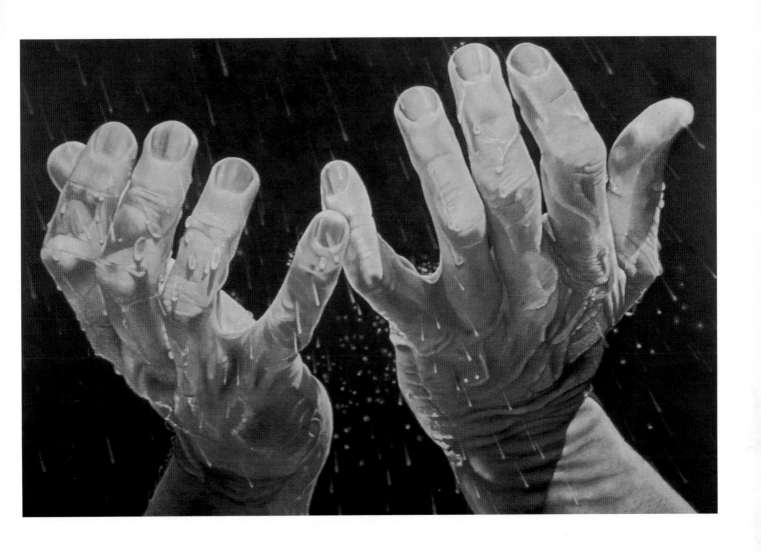

**BONNIE AUTEN, CPSA**

Derwent Award for Outstanding Recognition

*Rain*

20" x 28" (51 x 71 cm)

Windberg Paper, Sage

I strive for a "spirit of excellence" in my artwork. To me, this means that the artwork should be well rendered, and the subject matter should have meaning beyond being "just a pretty picture." As with the other hands I've painted in this series, this is a symbolic picture with religious meaning. These hands reach out to the sky. The rain is falling on a parched and drought-filled world. What was once an element to run from has evolved into a heavenly reason to rejoice. So it is with spiritual rain, which figuratively, is the Word of the Lord. Fine art must catch the eye and hold the heart.

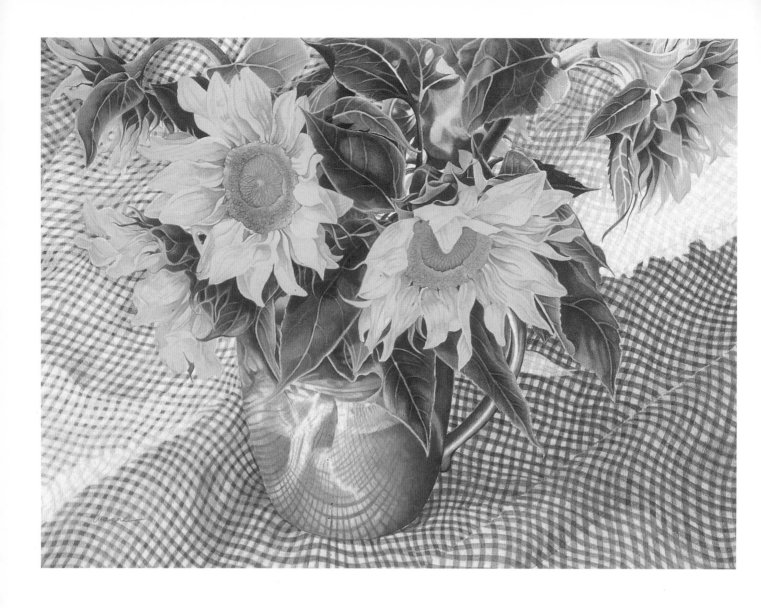

### LUANNE D'AMICO, CPSA

*Sunflowers*

30" x 38" (76 x 97 cm)

Rising 2-Ply Museum Board, White

My passions are gardening and colored pencil painting. I am not quite sure whether I garden to grow subject matter or whether I paint because I am so moved by the sights in my garden. I paint these fruits and flowers in their natural state, or I pick and arrange them, alone or combined with other objects. The purpose of all this—from the chosen subject and careful study of color to capturing the light reflections and shadow patterns—is to evoke a feeling of suspension in a moment when all elements within one point of reference are working in harmony.

**KATHLEEN M. DUNPHY**

*Elinore's Table*

20" x 26" (51 x 66 cm)

Arches Cover, Black

Working on black paper is a natural approach for me; the drama starts with the first stroke of a pencil. I color every inch of the paper, analyzing the colors of my subject like a chef cooking a complicated dish. I try to determine the "ingredients" in each color and then combine these hues in various amounts until I get the right "flavor." Making the eggs in the work the focal point allowed me to explore the colors of their white shells, and I rendered them without the use of a white pencil. Altering the undulations in the fabric became the most enjoyable part of the work. In the end, I turned the chaos of the intricate pattern and wood grain into a quiet, classic-looking composition.

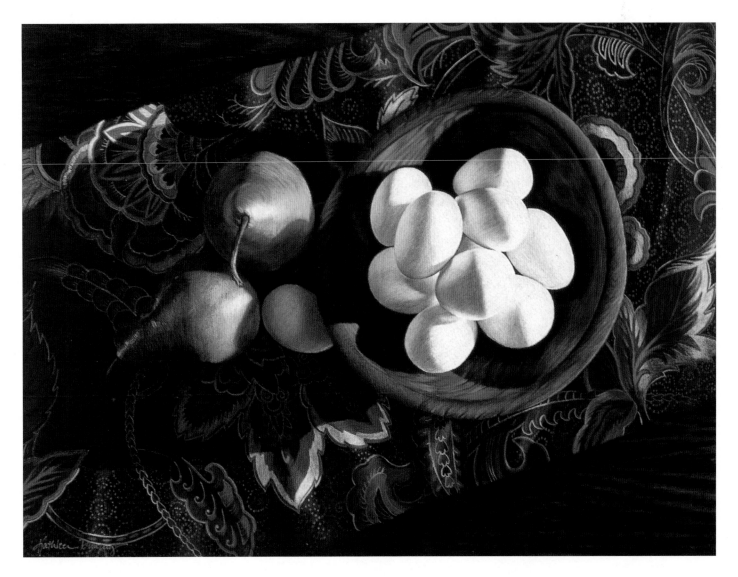

**DR. CHRISTINE J. DAVIS, CPSA**

*Iris VIII: Study In Buff*

22" x 15" (57 x 39 cm)

Canson Mi-Tientes, Buff

My husband, Tom, grows flowers, and I gleefully photograph them as they bloom and fade. I have over 1,000 photographs that I have taken over the past three years. If you saw the reference photograph from which I worked, you would know that this drawing was not a replica of it. However, those who see my work often say, "it looks just like a photograph." In addition to capturing color, I am motivated by an arresting point of view. I want the viewer to see an ordinary item from nature in a new way. This is the ultimate challenge with floras, which can be common, dull, and trite.

**SUSAN D. GUTTING**

*This ol' Sheep*

17" x 22" (43 x 56 cm)

D'Arches 140 Hot Press, White

We are relatively new to rural life. As I go through my daily tasks, I'm always thinking about what to paint: light, dark, contrast, color, expression, etc. There is a never-ending source of subject matter to portray. I waited a long time for it to snow so that I could do this painting. The muted light from the lowered clouds really set the mood—peaceful and quiet, with a touch of melancholy. Applying delicate layers of color in very small, circular strokes allowed me to retain the softness I love.

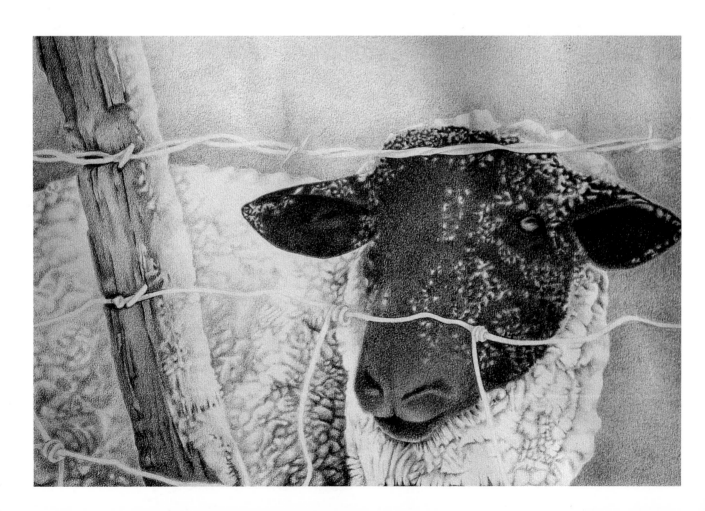

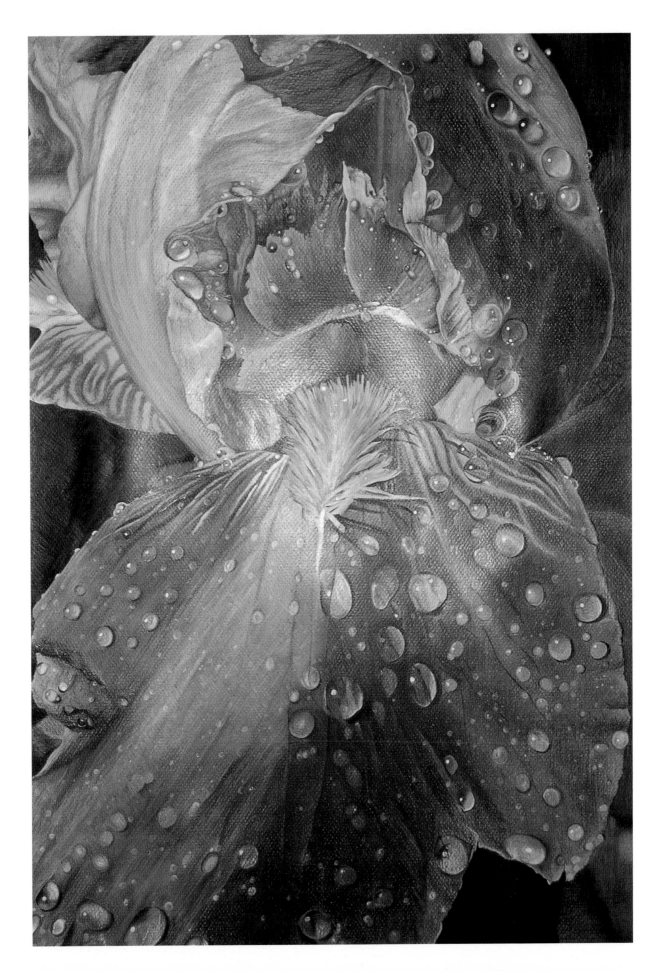

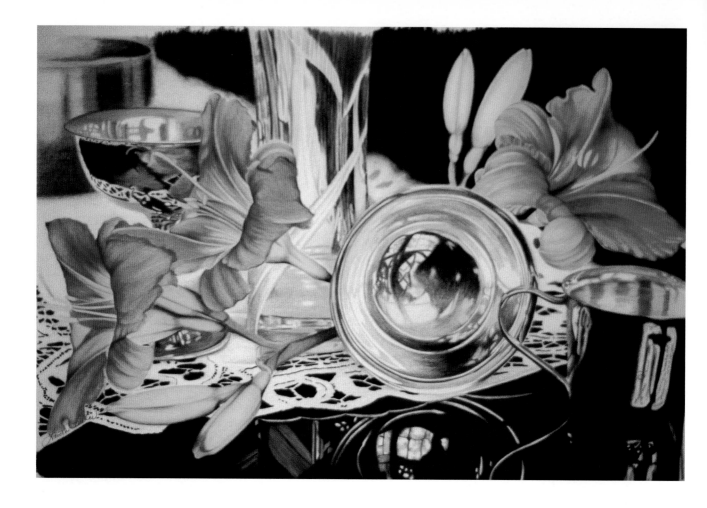

**LAURA FISHER**

*Afternoon Reflections*

14" x 21" (36 x 53 cm)

Strathmore 100 Smooth Bristol, White

I worked for years as a corporate creative director and as a graphic designer, which, in one respect, have both certainly influenced my artistic goals: I now create to please myself and not a specific client or market. This is an incredibly freeing experience. I find that my work has become not only more meaningful to me but to others as well. The objects in this image are particularly significant to me and symbolize my family. The intensity of detail in this arrangement and the multiple levels of reflection were an irresistible challenge. When someone once asked me what color I used to depict silver, my reply was "every color of the rainbow if the need arises."

**JACLYN WUKELA**

*Parking Lot*

22" x 18" (56 x 46 cm)

Windberg Sanded Paper, Black

After returning from a trip to Venice, I had difficulty capturing the feeling in my work that I had when I was there. I decided I was trying to say too much; so I chose this simple composition. When working in other media, I'm much more impressionistic, capturing just the essence. Not so with colored pencil. With this medium, I want to wallow in detail, immerse my viewer in richness, from the dark water to the high-tide mark left on the crumbling building. I didn't want to paint boats against a wall. I wanted to paint Venice!

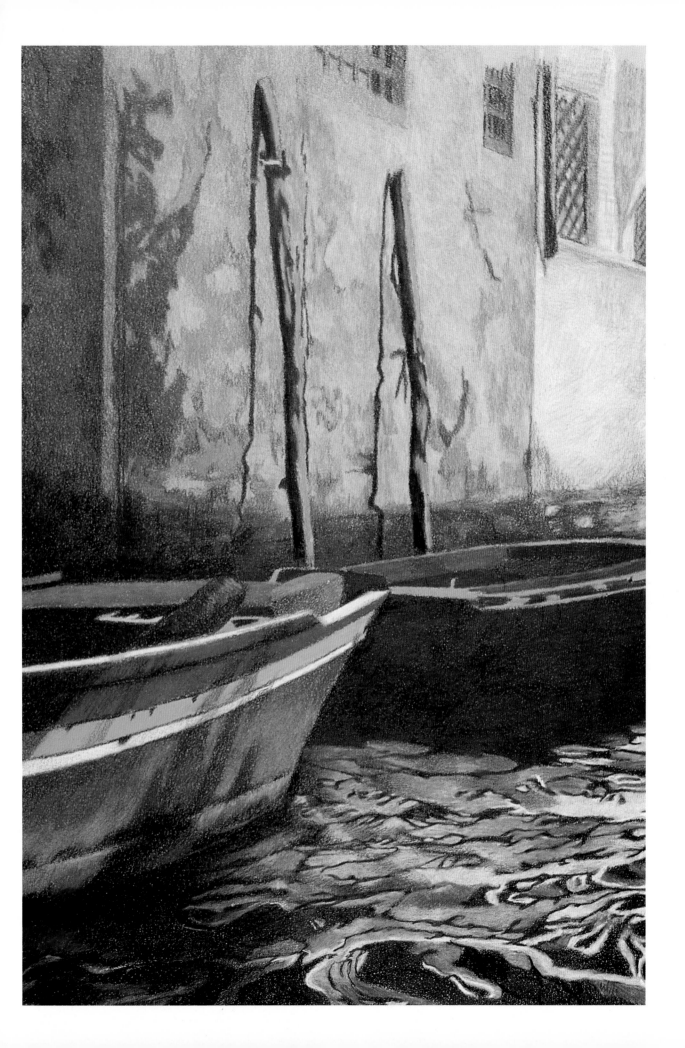

**CHRISTINE SYKES**

*Cowboys Never Die*

11" x 14" (28 x 36 cm)

LetraMax 24-Ply Illustration Board, Super Black

This is a portrait dedicated to all the cowboys I encountered at a Fort Worth, Texas rodeo. Being from Massachusetts, I realize this first experience influenced my understanding and appreciation of this event. I used several photographs and an old American flag for reference; but I was truly fascinated with my photo of an old cowboy with gray hair and a black hat. His clothing, mannerisms, and stance gave a cool, proud persona. Yet, his eyes intimidated me with his almost threatening gaze. I wanted to contrast the clown-like make-up with his almost sinister expression to create an expressive portrait. I wanted to show the story behind the face.

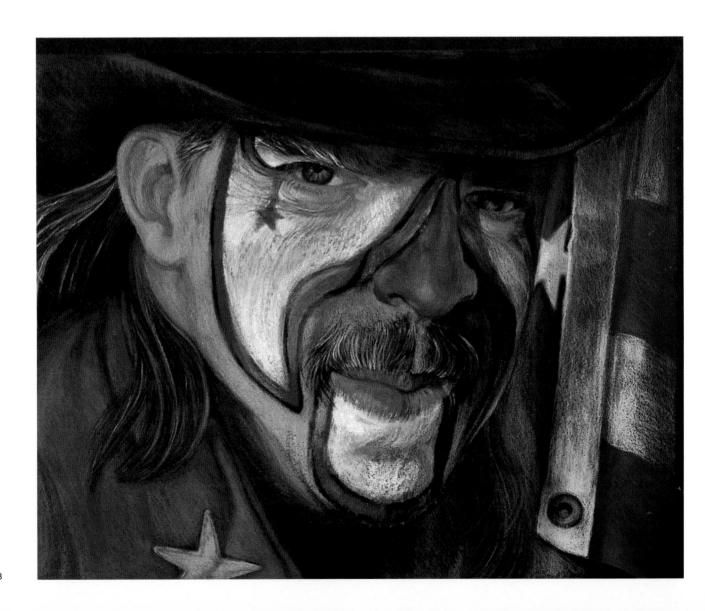

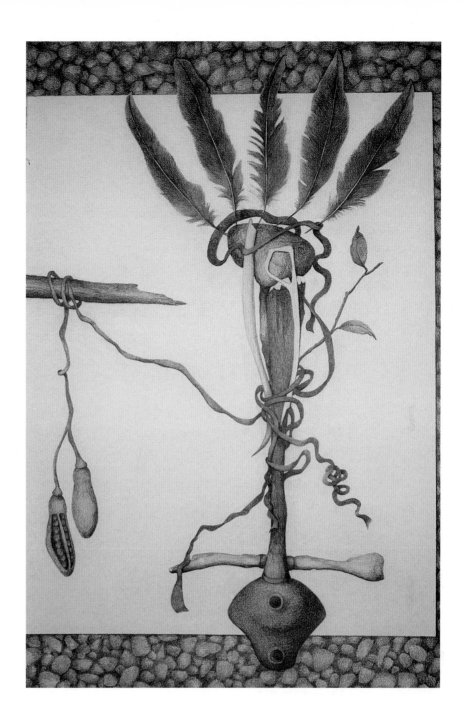

**SUSAN MART**

*Collections I*

28" x 18" (71 x 46 cm)

Rives BFK 250, White

During daily walks on city streets, along sandy lake shores or through wooded acres, I gather small objects: twigs, stones, leaves, bones, feathers, bits of plastic, metal, or string. I enjoy the ritual of gathering the lifeless, lost, or discarded fragments. My accumulation of "stuff" has become the basis for a new series of work. By using references to other cultures, I wanted to show these objects as ceremonial instruments infused with magical energy. I thought of this instrument as a prized specimen and presented it on a white background, like the ones found in botanical illustrations or in museum cases. The rocks under the white page provide a sense of place and enforce the perspective of looking down onto the subject. This series combines my found objects with my life experiences.

# E. Michael Burrows

*Jeeping*

22" x 29" (56 x 74 cm)

Somerset Satin Etching Paper, White

Everything is on the move to somewhere else. It's a simple statement, which is my way of summing up what I consider to be one of the most profound concepts of the natural world. It is my personal experience and knowledge that all of nature is in constant flux; if I sit and watch long enough, everything will move. Also, another fact that I've become aware of, living in the West my whole life, is that atmosphere is not a great factor to my vision. Because of the altitude of the Colorado plateau, where most of my rock formations I draw are found, the eye can perceive details tens of miles away, and in some areas, hundreds of miles away. It is important to me to convey this sheer wealth of visual abundance in my work.

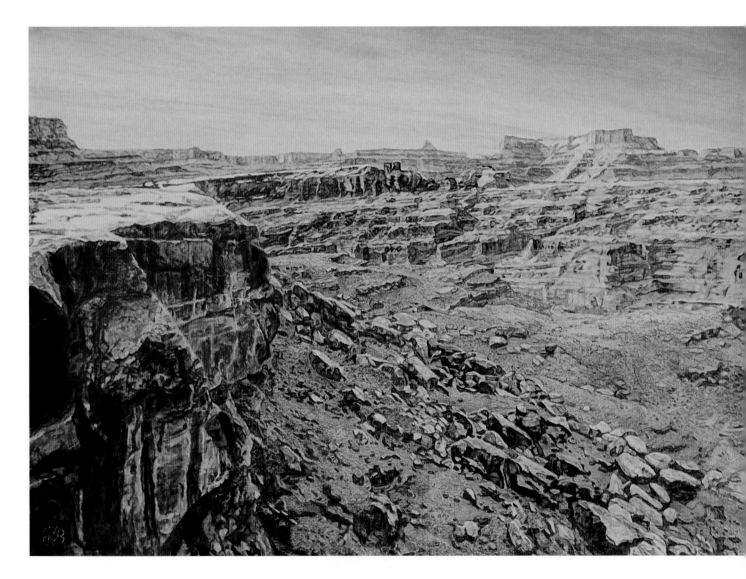

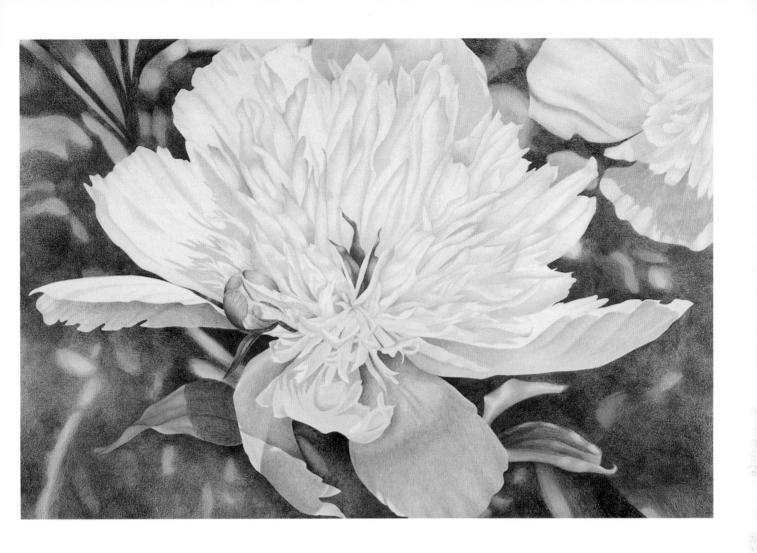

**PRISCILLA HEUSSNER, CPSA**

*White Peony II*

22" x 30" (56 x 76 cm)

Rising Stonehenge, Pearl

My primary subjects are floral close-ups. I am fascinated with the beauty and intricacies of a single bloom, and the thousands of varieties and colors give me an endless source with which to create. Re-creating the beauty of nature is an impossible task—I can only hope to capture something that invites the viewer to take a closer look. I begin by concentrating on a particular element, such as the many colors hidden in a single white petal, the gracefulness of a blossom, or the contrast of a brightly colored flower against the dark green leaves. By simplifying the picture, I can express the beauty of the subject through exaggeration and make it come alive.

81

**MARTHA DeHAVEN, CPSA**

*The Sweet Side*

15" x 11" (37 x 27 cm)

Canson Mi-Tientes, Dark Gray

Great paintings can make me cry. All of my work is influenced by Dutch and French painters of the seventeenth and eighteenth centuries. In this painting, as in most of my work, I used dramatic side lighting called chiaroscuro that was often used in Dutch painting. It was exciting to use this Old World technique with modern objects and materials. Although I don't specifically set out to do it, most of my work has several common compositional themes: color, light, and texture. The common emotional theme is tranquility.

**WARREN J. INGALLS**

*Autumn Of My Life*

14" x 25" (36 x 64 cm)

Strathmore 500 Cold Press Illustration Board, White

My drawings are done in great detail. In this particular work, the leaves are from a fruitless pear tree off my back patio. Each autumn, the leaves change to a variety of greens, reds, yellows, and oranges. And in the late afternoon, the sun creates a brilliant display of color and shadow. I knew I would someday capture this branch on paper. As I began working, I thought of our life span and how it relates to the growth and death of these leaves. And that began to play a motivational roll in depicting a very small piece of one of nature's most beautiful seasons.

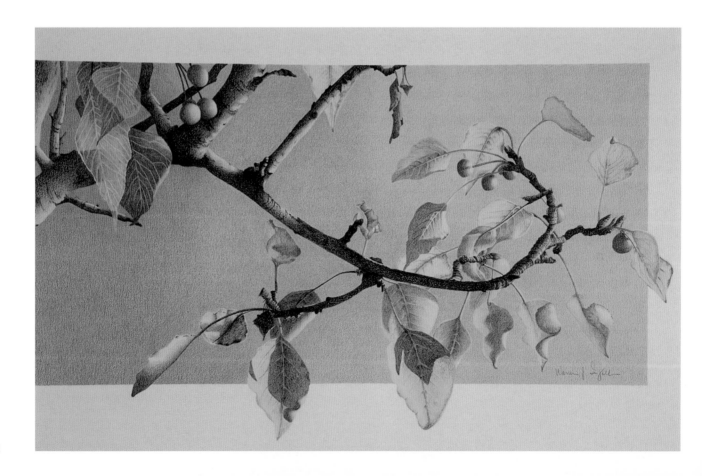

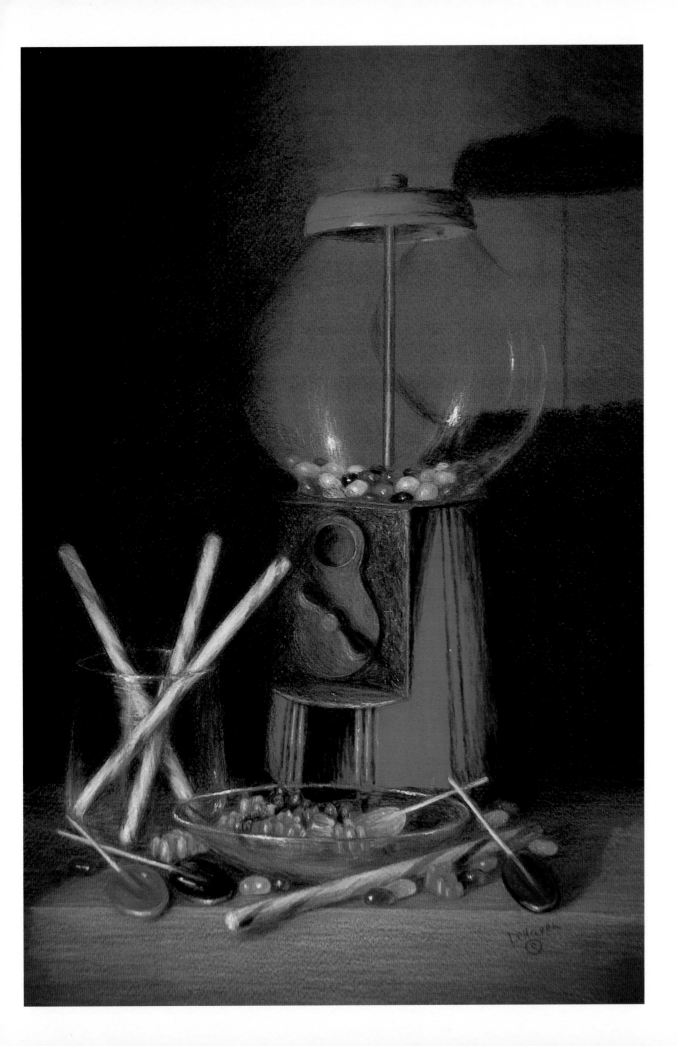

## DON PEARSON

*Hangin' On*

15" x 11" (38 x 28 cm)
Crescent Mat Board, White

Some things are permanent, like the rocks depicted in this work. A glacier carried them here 13,000 years ago, and they're still here. The old root in the center? It's surrounded by all the new growth coming to take its place. And that ground squirrel on the left just doesn't give a damn about any of it because he lives in his world day-by-day. I relate to that root. We're both old, gnarled, and scarred, but we're both still "Hangin' On."

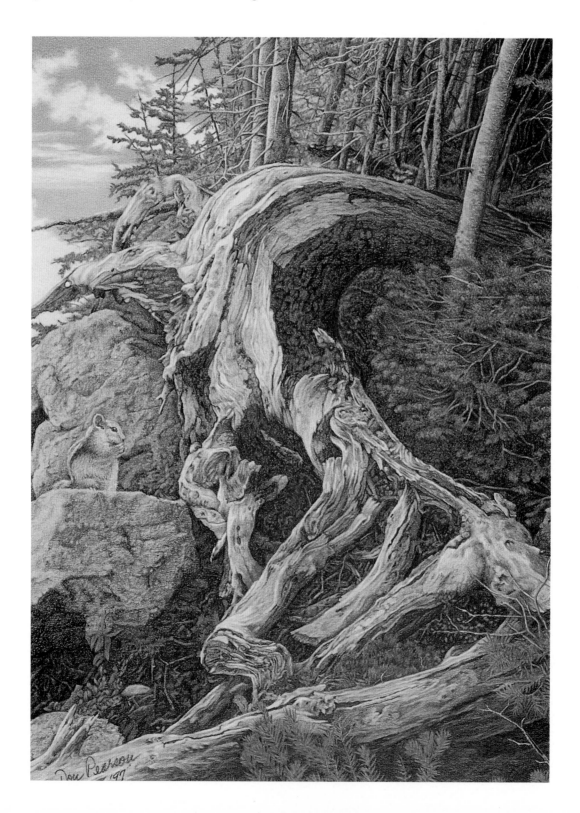

**PHILIP BRULIA**

*Through The Portal*

38" x 27" (97 x 69 cm)

Bainbridge Alpha Board, Black

There are certain visual artists, musicians, writers, and directors whose work conveys such a powerful feeling, mood, or atmosphere that you feel transported to another time or place. Their work transforms your way of looking, hearing, or thinking. That is what motives me. I strive for that transcendent quality in my work—to create something that leaves a lasting impression and captures a moment that is "timeless."

**DANIEL HANEQUAND**

*The Ethereal Dancer*

20" x 16" (51 x 41 cm)

Strathmore Paper, White

The idea for this drawing stemmed from an accumulation of ideas stimulated by music. Dance is a subject particularly dear to me. Its movement inspires and enhances our human qualities as well as our mental vision. This painting of a dancer with a dual personality was, as are all my works, done from imagination. I combined surrealism and symbolism to express an idea. The intent of my work is to discover the unknown.

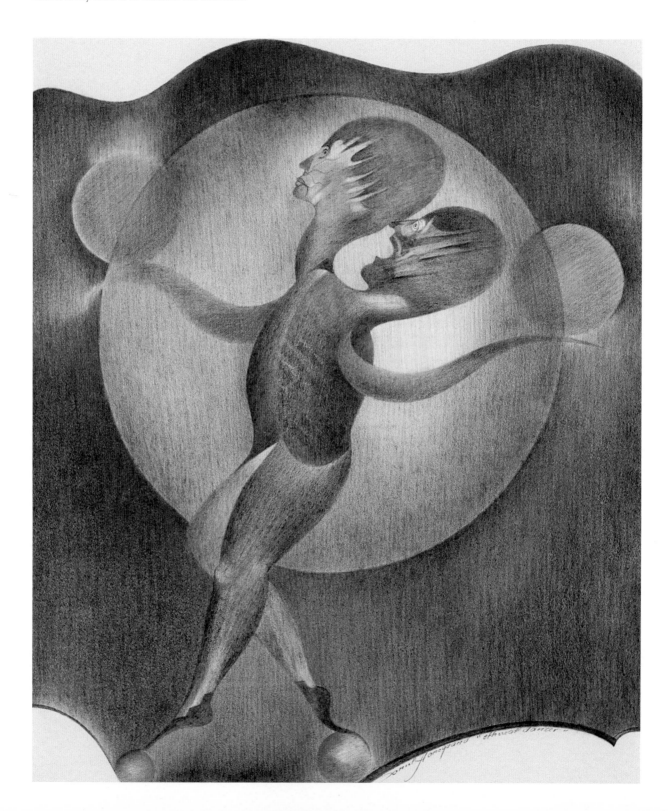

**MIKE RUSSELL**

*Wing Nuts*

19" x 15" (48 x 38 cm)

Museum Board, White

"Wow, Mike, what does it mean?" "What gave you the idea?" These questions are usually followed by an abrupt, but all too common, "Why?" Like any art process, this artwork began with a concept, an idea that developed and was translated by me for others to view. After I had the concept for this work in mind, I researched for reference materials. The more you understand how something is put together, the better you are able to draw it. I generally use an initial sketch to resolve as much as possible—cutting pieces out, repositioning, or rescaling as I go. Once the sketch is transferred to my drawing surface, I turn colored-pencil wax into diamonds.

**MARILYN GORMAN**

*Diamonds*

31" x 31" (79 x 79 cm)

Strathmore 500 4-Ply Bristol Vellum, White

My studio is blessed with an on-going stream of young people. My college-age
son and his friends are always welcome, and I often study them. I observe
that these young, articulate, sensitive, and generous personalities are often
wrapped in rather "rude packages." Their visual statements are actually a
form of social "armor" and act as a layer of safety in a complex and threaten-
ing world. The piercings and tattoos and never-ending attitudes seem to ward
off evil spirits much like tribal body art would in another culture. And behind
it all, I see such marvelous potential and am compelled to record this strange,
sociological phenomenon. I leave idealized youth for other artists. I prefer

painting the kids on the fringes.

**ELAINE L. BASSETT**

*Flood Dance*

15" x 16" (38 x 41 cm)
Canson Mi-Tientes, Light Blue

Process is the most important thing to an artist, not the finished work because it's during this time that we struggle and learn. The original inspiration for "Flood Dance" began in our orchard during the fall. I started by working lightly with subtle tones. But when the leaves were gone and winter came, I made the pencil layers thicker and thicker. Soon, I was lost. The painting wasn't working. When the spring floods hit our area, I dreamed of deep, black water, and I finally knew how to resolve this painting. I would change my technique. I scraped off layers, lifted out entire areas with mineral spirits, and reworked the piece until the painting became something entirely different. And yes, I learned a lot in the process.

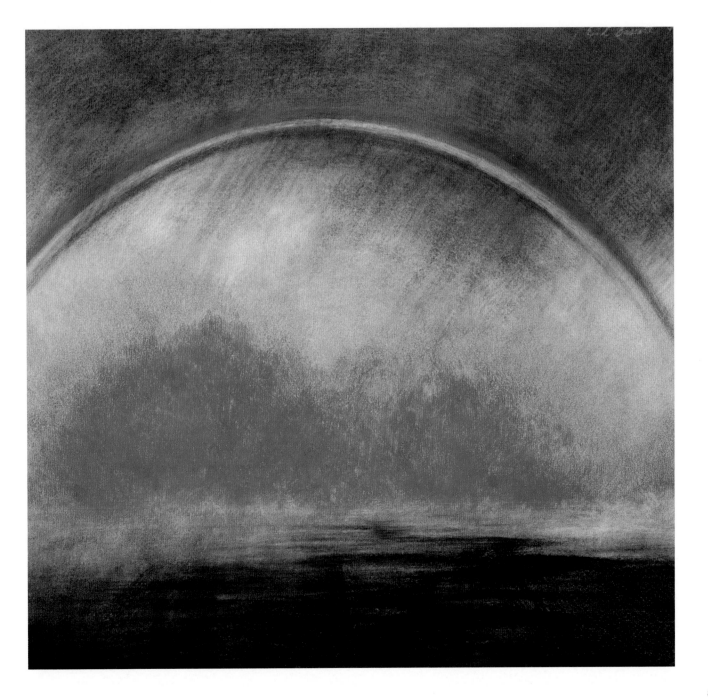

## HEIDI W. SCHMIDT

*Three Marbles*

21" x 15" (53 x 38 cm)

Strathmore 500 Bristol, White

It's magical to take an idea, begin to develop it on an empty two-dimensional surface, and then finally see it come to fruition. It's the vision of your mind's eye produced in tangible form. Working on this piece was a complete joy. I was lost time and again in the abstract qualities of the marvelous dance of color, light, and design.

## SYLVESTER HICKMON, JR.

*Sun-lit Apples*

18" x 24" (46 x 61 cm)

Winsor & Newton 140 lb. Hot Press, White

Artists are a unique breed of individuals. We have a special way of seeing that brings us closer to every detail and subtle nuance of color around us. How many people, for instance, would notice the shimmering hints of indigo blue in the shadows of the apples or how they throw a red cast onto the surface. Since I prefer to render these precise details, I use the viewfinder of my camera much like a sketchpad. The camera is an indispensable tool for establishing composition, preserving the spontaneity of lighting and mood, and capturing realistic details. I want the viewer to be drawn in by the rich, warm, tranquil setting I create and find that still lifes are a never-ending source of color and exhilaration.

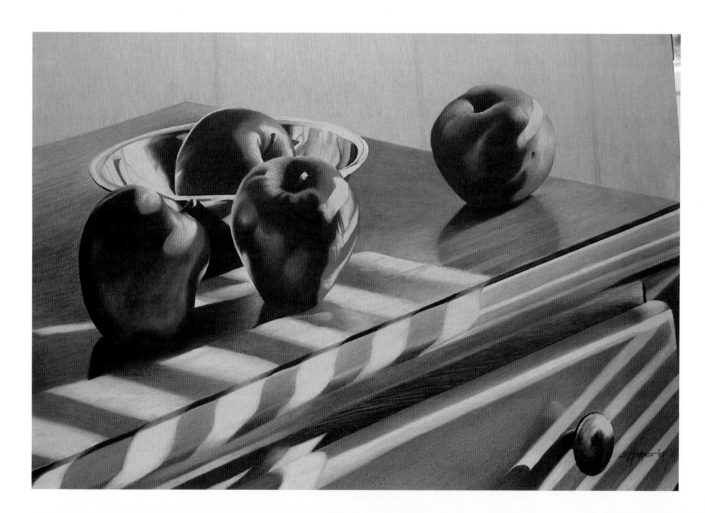

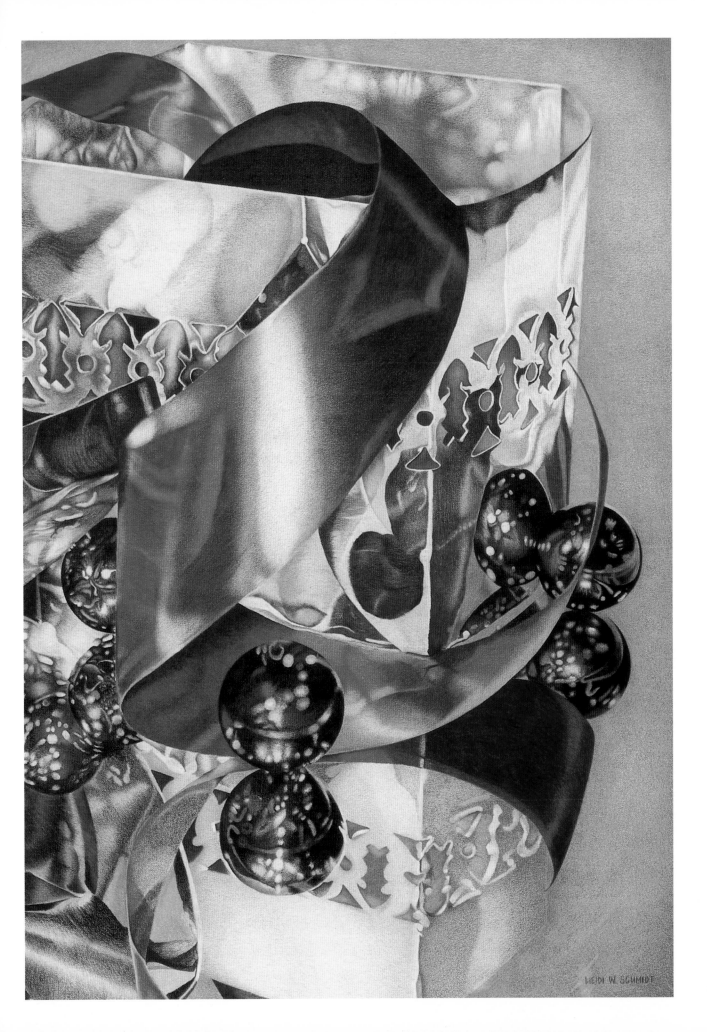

HEIDI W. SCHMIDT

91

## SUSAN L. BROOKS, CPSA

*Blueberry Hill No. 3—The Trinity*

22" x 18" (56 x 46 cm)

Windberg Pastel Paper, Light Gray

My *Blueberry Hill* series is actually a play on words. As a child, I played on a farmland in southern Ohio, which was owned by the Berryhill family. The woods there were dark blue and green and quite luscious. Every blossom and petal appeared larger than life. It's an image that is still etched in my memory today. As I keep exploring this motif, I find that the designs just come to me without thinking much about them. It's only when others find some significant idea buried symbolically in the shapes that I discover some subconscious thoughts coming through my artwork, thoughts that I can't seem to express verbally.

## KIMBERLY MULLARKEY, CPSA

*Gleditsia Triacanthos*

11" x 15" (28 x 38 cm)

Cold Press Illustration Board 100, White

As a teacher of botanical illustration, I am fortunate to be able to spend many hours enjoying nature. Even the simplest forms have such complexity. And a humble object like a dried pod has a whole world within it—movement, texture, color, etc. My artwork is about how I connect to my inner self and to the world around me. It is my search to make sense of my surroundings and to give meaning and order. I draw to praise this incredible world in which we live. I draw to be transported to another place. By working on a small scale, I create intimacy and invite the viewer to come closer to the work.

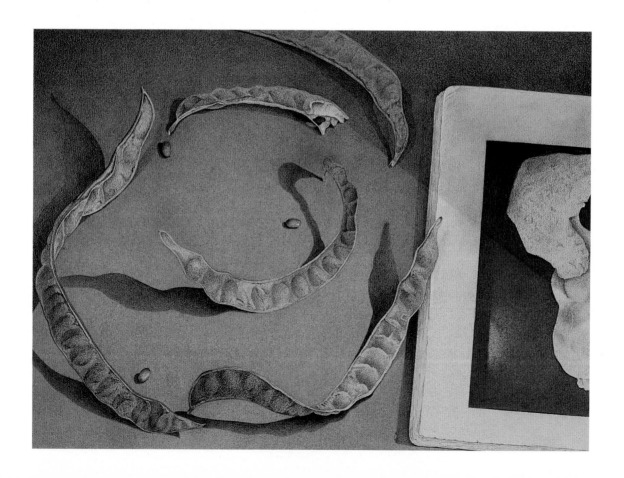

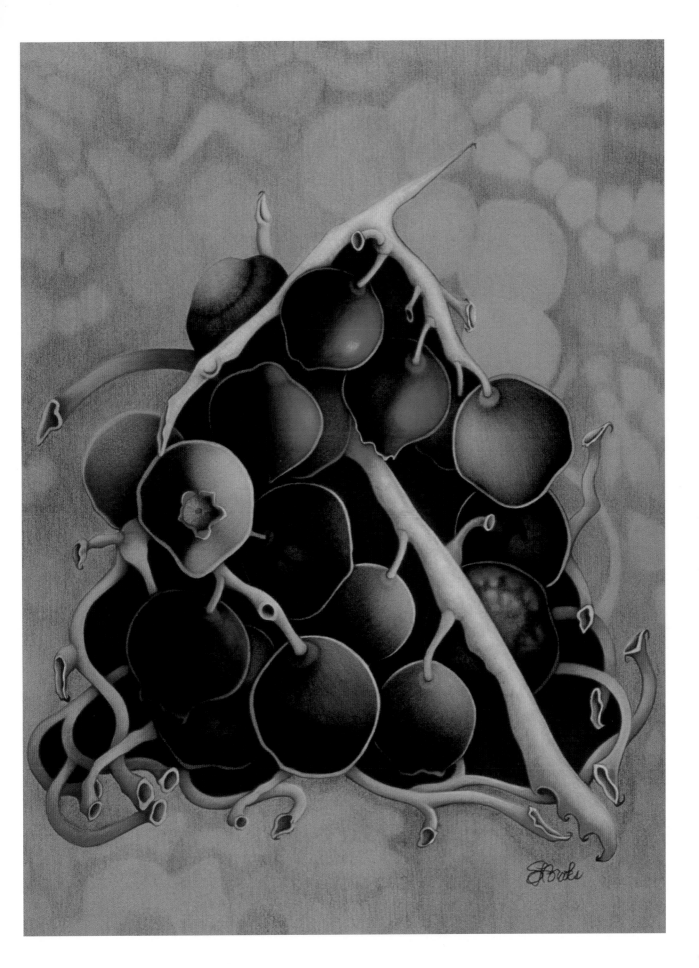

**JOHN TOLOMEI**

*Toy Boat*

22" x 30" (56 x 76 cm)

Arches 140 lb. Hot Press Watercolor, White

My wife and I have two kids and share child-rearing duties. So, I feel like toys surround me. One day I just started shooting close-up photographs of various toys around the house. I was attracted to the colors, shapes, and simplicity of the toys and the close-up quality that made them appear larger than life. I like working with single-subject still lifes rather than ones filled with multiple objects. More is not necessarily better. In this way, the viewer can look at the subject in a way that they would not ordinarily see it. I hope that those who see this drawing can feel the sense of wonderment a child has with toys.

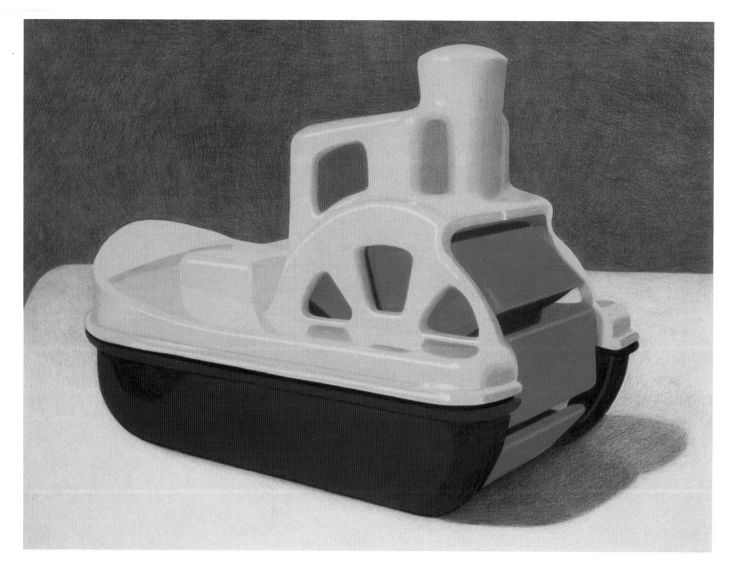

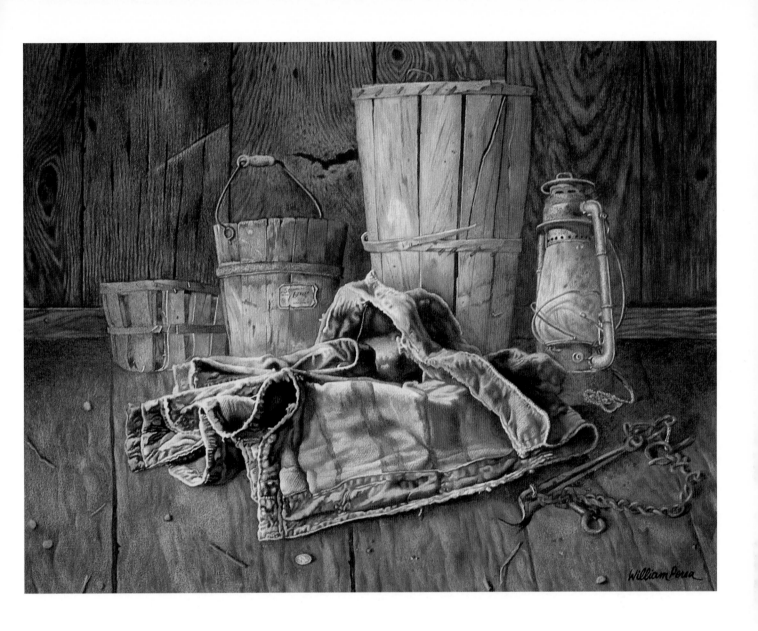

## WILLIAM PERSA

24" x 30" (61 x 76 cm)
Strathmore Illustration Board, White

In my forty-seven years as a commercial artist, art director, and illustrator, I didn't have the time or energy to create fine art. Now, since I retired, most of my paintings are related to the farm area where I have my home and gallery. My father-in-law's old, tattered, denim, Sears-Roebuck jacket, a farm lantern, barn floor, wagon chain, turnips, grinding wheel, and silo fill me with the joy of painting. I try to get a three-dimensional effect in everything I render, and good drawing is the key. A nostalgic feeling, a sense of remembering, a joy of familiarity, a love of nature—it's beauty and function. These are the things I would like viewers to experience in my work.

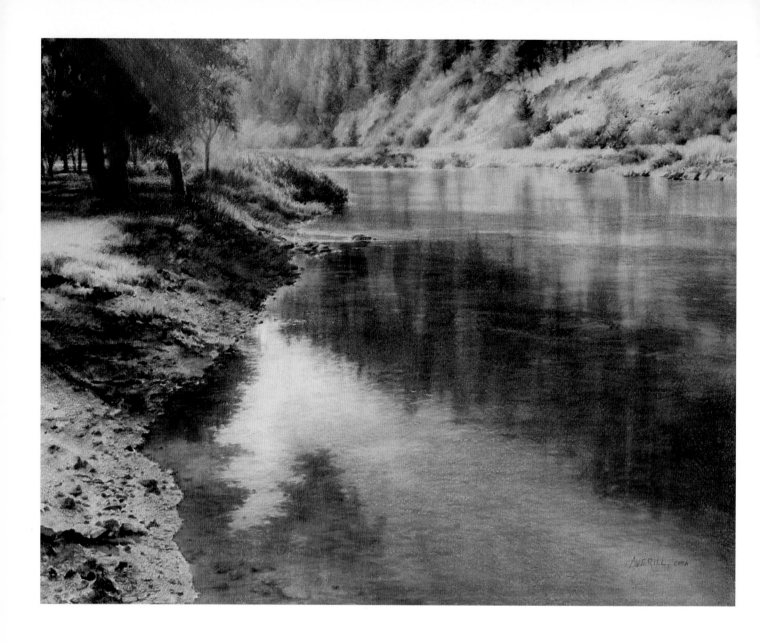

## Pat Averill, CPSA

*Hilgard Camp*

14" x 18" (36 x 46 cm)

Bainbridge Alpha 4-Ply, White

I look at nature as a whole entity with slight variations rather than as a group of individual components. Edges that meet, overlap, or disappear—one fading into another—are what I see. I never pay much attention to actual details in my reference photos but use them to help me remember the essence of a place. And then I work intuitively, turning slight imperfections into "textures" that become rocks or paths. Creating art feels good! I can let go of ordinary concerns and allow myself to run wild with personal visions—imagining that I am still looking through the water to the stones below, feeling the breeze through my hair, and hearing the wind in the grasses. The soothing forces of nature and the power of viewing life with optimism move me.

## KARLA MANN

*Mardi Gras*

19" x 15" (48 x 38 cm)
Canson Mi-Tientes, Dark Blue

Detail and realism inspire me and are the driving forces in my creative expression. "Mardi Gras" began with my fascination of masks and how they are used in different societies. In our society, masks are mostly used for decoration or costume parties, and the combination of fabric and mask made me think of the festive celebrations of the Caribbean Islands. In this painting, the reflection of the fabric pattern in the metallic surface of the mask gave the impression of plumage, adding to the concept of a costume. This intrigued me. I intensified the colors to accentuate the festive mood and folded the fabric to suggest that a figure may actually be supporting the mask.

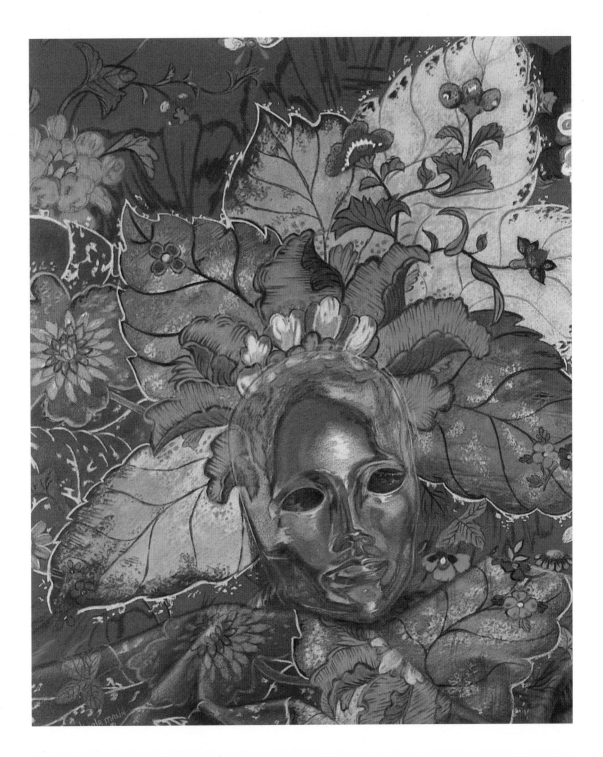

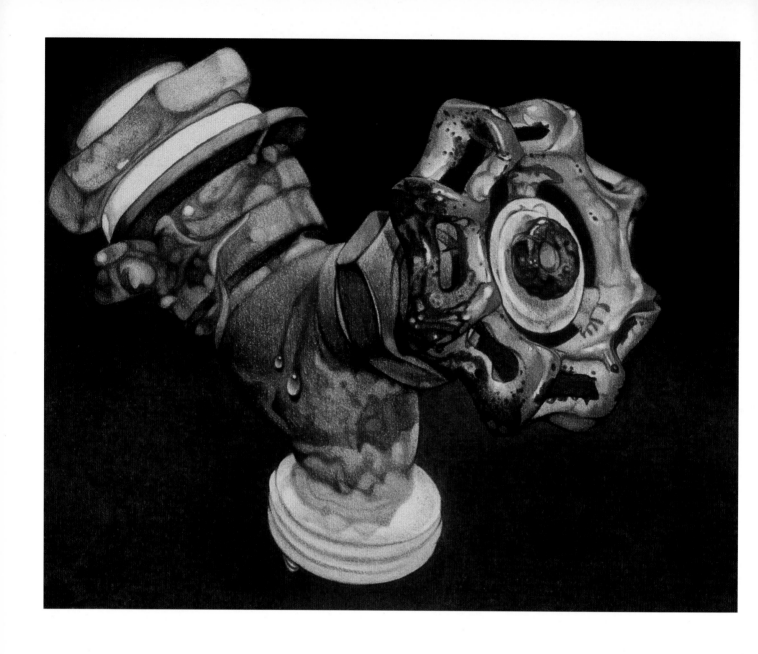

**CHRIS LaMARCHE**

Friends of CPSA Award

*The Last Drop*

10" x 11" (25 x 28 cm)

For me, colored pencil is the best medium for creating photorealistic images. I am interested in looking at everyday objects from different points of view, altering them so that they are presented in a new light. This painting is a result of my visit to a railroad museum. While I was there, I was attracted to this bright blue, rusty handle. And I added the two water drops on the side of the spigot at the last minute.

## MUTSUMI SATO-WIUFF

*Singing Lake*

18" x 23" (46 x 58 cm)

Canson Mi-Tientes, Steel Gray

The idea for my first colored pencil landscape came when a watercolor artist implied that colored pencils are great for cute illustrations but not for serious painting. It was a challenge. Once I made up my mind to do the landscape, I became particularly interested in light, air, and water. I was motivated by varieties of sunlight—the sparkling water ripples, the spotlight effect through the moist summer air, and the blinding beam from a crack in the clouds. The visual experience became so intense that it awakened my other senses. I noticed the smell of wet soil on the lakeshore and the far off rumble of thunder. I wanted to capture the whole scene, not just visually but also psychologically and emotionally.

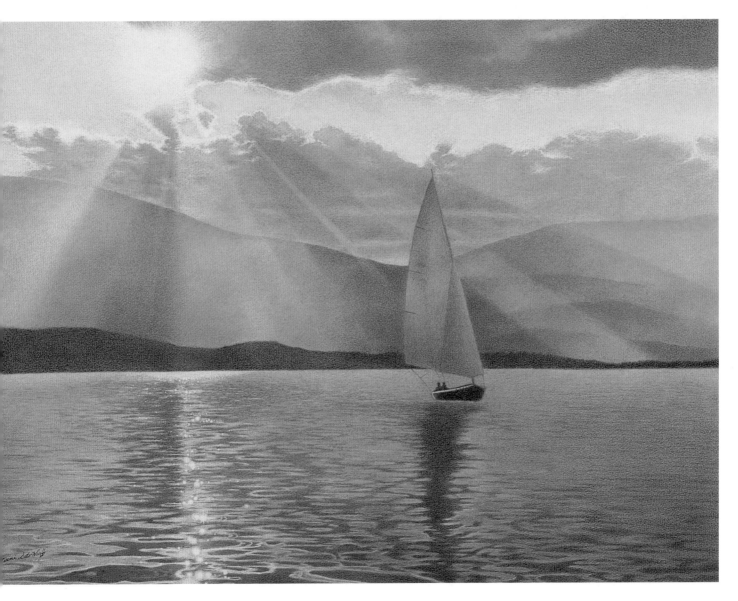

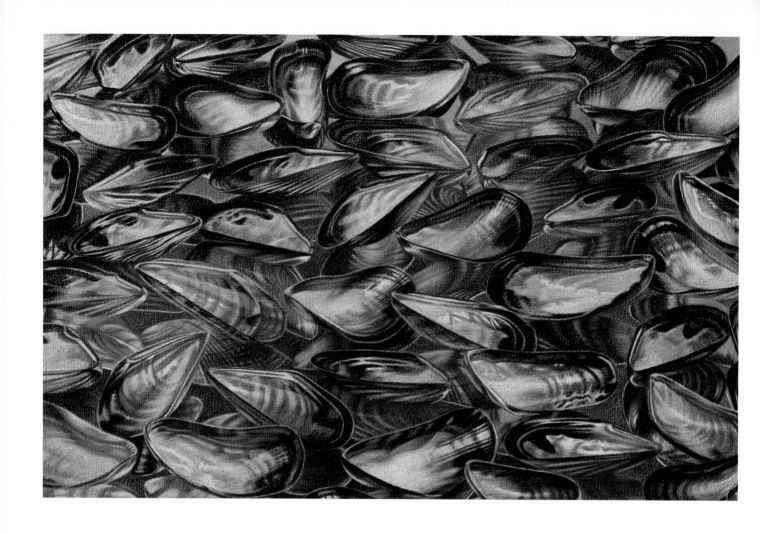

### DENA V. WHITENER, CPSA

*Mirrored Remains*

9" x 13" (23 x 33 cm)

Strathmore Mi-Tientes, Flannel

At first glance, all mussel shells look similar. But after looking at them, I find
a great variety of colors and shapes, along with transparent and reflective
qualities, become obvious. Holding one shell to the light, I was thrilled to
discover incredible colors: deep oranges, golds, and violets. In this drawing,
I used one light source shining down on the shells in my darkened studio. To
enhance the colors, I arranged shells on a mirror, and then glued them in
place with a hot-glue gun. This kept them from shifting in the weeks it would
take to complete the drawing. While I find my work as a commercial artist
rewarding, my true passion is in the drawings that come out of my small
studio.

## GAIL McLAIN

*In The Pink*

13" x 18" (33 x 46 cm)

Rising 4-Ply Museum Board, White

Ideas are everywhere. Some grow out of others, some just happen. But it also feels good to put pigment on a surface, to hold a pencil or brush, or mold a piece of clay. When I see something that captivates me or evokes my emotions, I need to capture it, hold it, and share it. No subject is impossible or inappropriate for colored pencil. Since I also do sculpture, the fascination of creating what looks three-dimensional on a two-dimensional surface revitalizes my artistic senses.

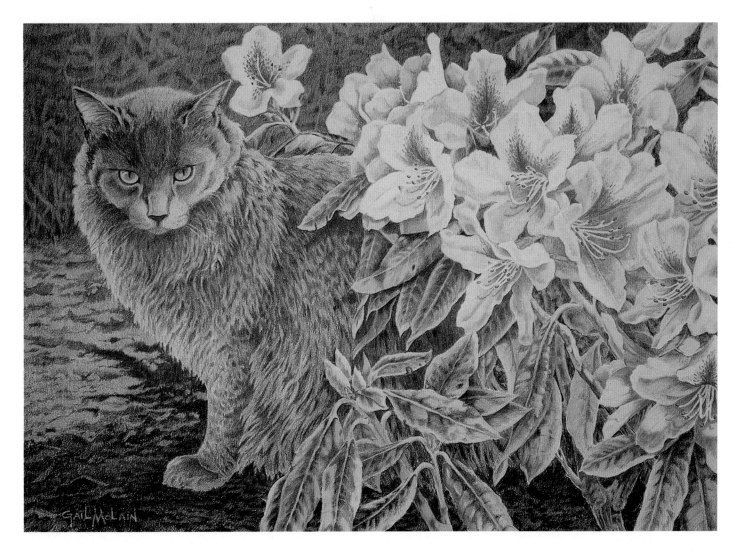

**GLENN L. HOUSEMAN**

*Globes That Float Over Concrete Moats*

7" x 7" (17 x 17 cm)

Strathmore 2-Ply Bristol, White

Every night after work, I would come home, drink beer, and just sit and stare
at this scene out my window. The sight of the freeway from twenty floors up
is hypnotizing. The absence of living things can be eerie, like an alien planet,
evoking loneliness. To me it was the beauty of pretty lights reflecting off
dirty concrete. I wrote this poem entitled "Beauty Missed" before I did
the drawing:

*The glow globes float*

*Over concrete moats.*

*Whizzing vehicles hiss their disregard.*

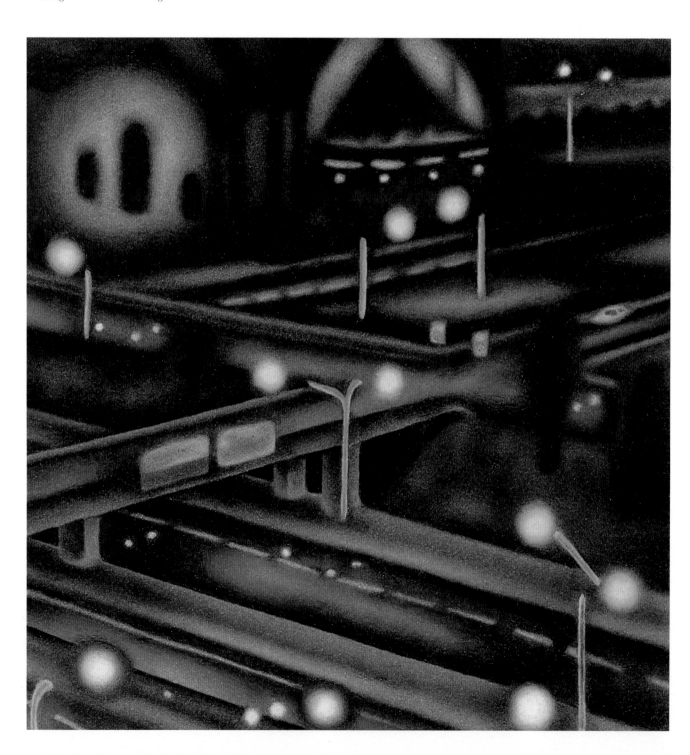

VIVIAN MALLETTE HUTCHINS, CPSA

*Twilight Values*

18" x 30" (46 x 76 cm)
Mat Board, White

For this piece, I purposefully limited my palette to explore the qualities of low light and low color present in the scene. The monochromatic color scheme gave me an opportunity to create a minimalist work, which challenged me to put in as little as possible while trying to say as much as possible. I employed the white of the paper as a palpable force in the image by using negative spaces as important design elements. Exploring the abstract qualities of the design, while still trying to make a realistic image was an interesting and stimulating problem.

**PRISCILLA HUMAY, CPSA**

*Performance Near Stern's School Road*

30" x 40" (76 x 102 cm)

Cold Press Watercolor Board, White

I have always been intrigued with wide-open vistas, but unfortunately this once common sight is now a rarity. It's becoming increasingly difficult to find a landscape that does not possess the intrusions of humanity—signage, tract homes, power lines, etc. I travel through rural areas to document these simple views. Clouds compel me to capture their changing forms. At times, the intensity of the drama changes so swiftly that I can only rely on fast notations and memory. Parked on the roadside, sketching through a windshield, open door, or window, I'm ever mindful of a nearing lightning bolt. In the smallness of this planet, I look for its vastness.

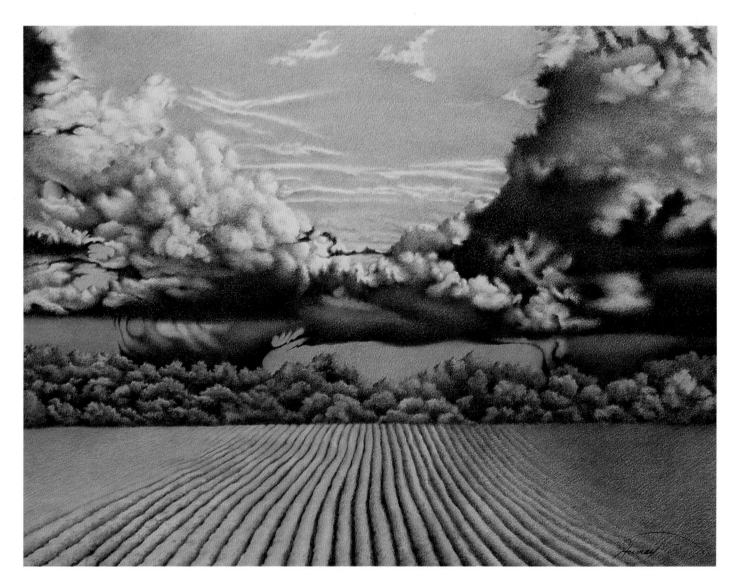

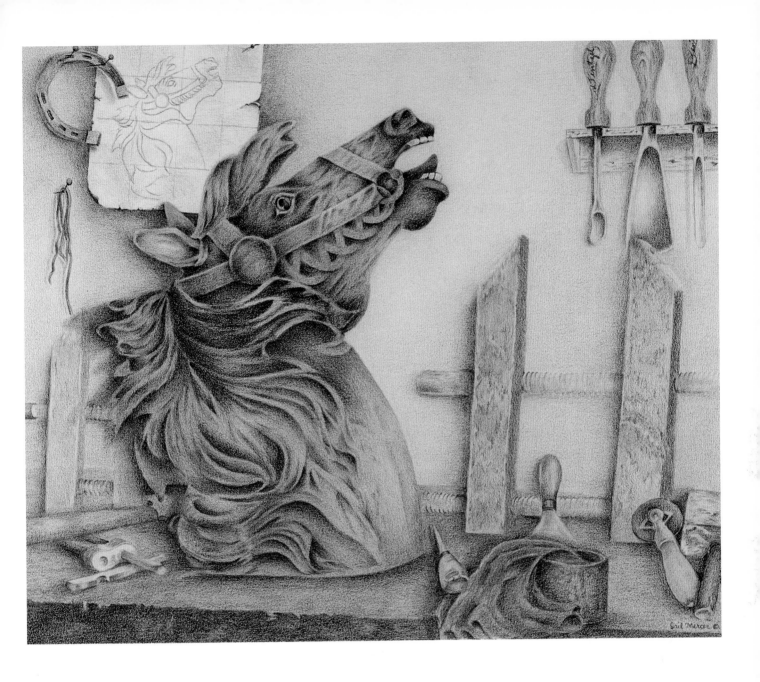

## GAIL E. MERCER

*Dentzel's Workshop*

14" x 17" (35 x 43 cm)

Strathmore 4-Ply Bristol Board, White

The Merry-Go-Round Museum in Ohio had on exhibit the workshop of Dentzel, a master carver of carousel horses. This beautiful head was part of the last horse Dentzel was carving at the time of his death and was the only part completed. The rest of the horse remains unfinished. The exhibition is truly a testament to the man who set the standard for the spirit and quality of this craft for his peers. I want others to know Dentzel's remarkable talents and the environment in which he was likely to have worked. Because of the historical significance of some of my subjects, I feel I have given them a new breath of life.

105

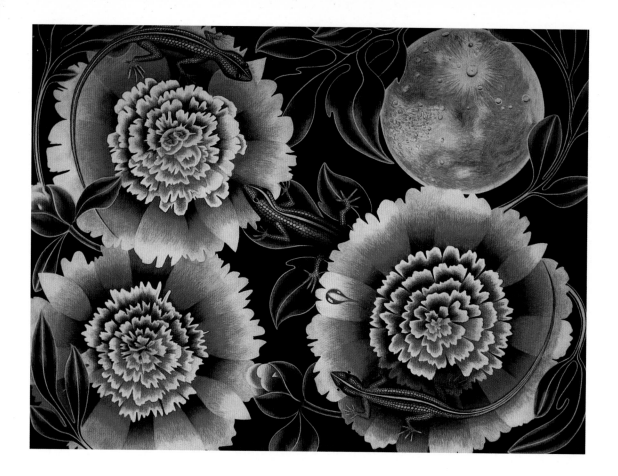

## GARY E. BACHERS

*Three Peonies & The Moon*
23" x 17" (58 x 43 cm)
Alvaflex Polyester Film

After I suffered a stroke, I lost the use of the right side of my body, an event that forced me to retire from my position as a general practitioner medical doctor. As part of my rehabilitation, I tried using colored pencils since they were easier to control than a paintbrush. Control was certainly an issue for me since I had never used my left hand for writing, let alone art. Today my daily, colored pencil work is still part therapy and rehabilitation; but just as important, it is a means of communication and expression, since I also lost my speech. Depicting detailed peonies with their countless small petals is challenging. But I think the work is very worthwhile.

## MAGGIE TOOLE, CPSA

*Moving Heavy*
40" x 30" (102 x 76 cm)
Walnut Wood Panel

To meet the CPSA Exhibition deadline, I had three days to create this work. The anxiety-filled timeframe forced me to go into a "I-don't-have-time-to-think" mode, or I fall into my standard, self-enforced rules using the "Circulism" technique I developed. I decided to plunge in and to go at it full force. I had no time to play with it or think it over. I had to trust myself and just let go. Thus, this image came easier than any before it. I dared to have more confidence in myself than ever before, and it worked. As the image emerged, I noticed this process had helped me look at a part of myself that I may have never seen before.

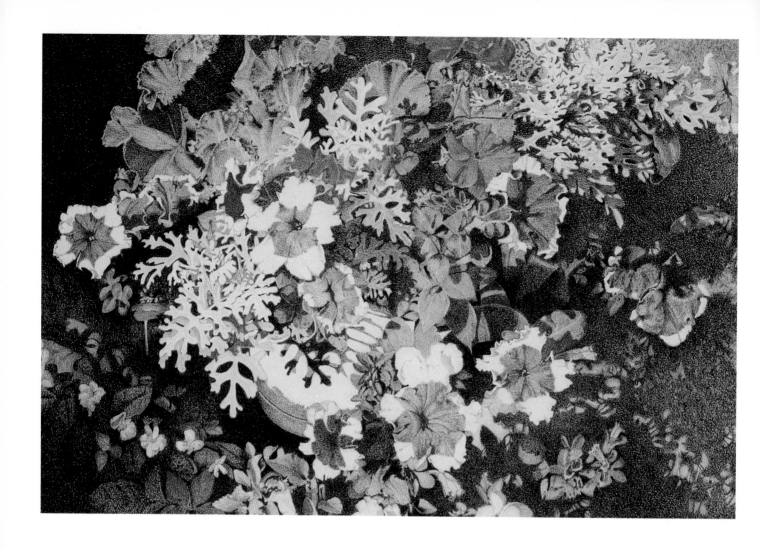

**RAYMOND TETZLAFF**

*Petunias, Begonias & Dusty Miller*

10" x 15" (25 x 38 cm)

Strathmore Illustration Board, White

As an architect, I hadn't thought of doing any "fine art" until my wife, Nancy, suggested I make our Christmas card. The first step was to decide in what medium I would work. I was surprised to find the variety and quality of the colored pencils offered at the art supply store quite different from the ones I remember from my school days. More impressive, however, was the variety and quality of the artwork that this medium could produce. This was fine art indeed! Doing that card was an absolutely stimulating experience. And I was hooked.

**WILLIAM A. BERRY, CPSA**

*City Planning With Blue Ball*
30" x 40" (76 x 102 cm)
Museum Board 2-Ply, White

For some time, I have been making large still-life drawings in colored pencil exploring the special visual qualities of geometric solids. Sometimes I add natural or man-made objects along side the geometric solids to form a visual and metaphorical contrast. The geometric solids represent an intrusion of an "ideal form of a truly platonic type" into the world of "objective reality," a visual event which I find both intriguing and poetic. It is the underlying theme in many of my drawings and is intended to make a metaphysical statement about the visual experience.

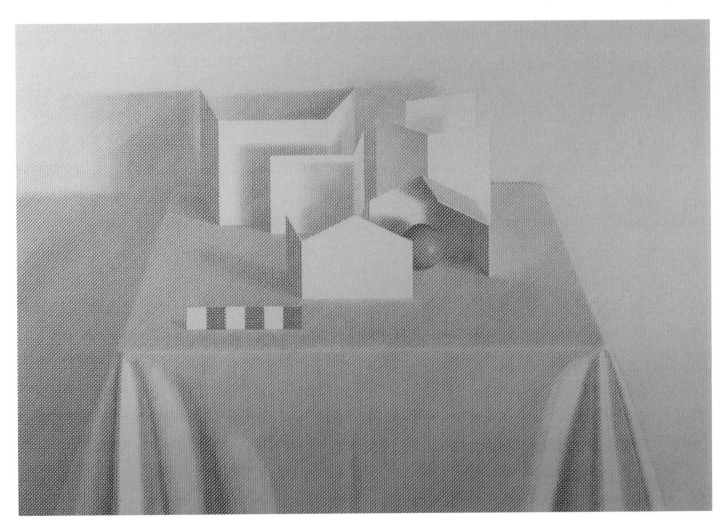

## LINDA FAULKNER

*Long-eared Owl At Sunset*
22" x 14" (56 x 36 cm)
Crescent Mat Board, Bright White

I never draw anything that I have not observed first hand. Living near Quail Hollow State Park, I have made the park and its inhabitants become the subjects of my artwork. During my regular wanderings through the park, I keep a journal/sketchbook of my observations; and I often begin many of my finished pieces from these notes, field sketches, and photographs. Late one afternoon, I was completely surprised to find this migrating owl perched in a tree. Since they are reputed to be strictly nocturnal birds and rarely observed, it was exciting to have this opportunity. I was able to take notes and photograph the owl for fifteen minutes while it sat staring at me with a surprised expression.

## ALLISON FAGAN, CPSA

*Beauty And The Beast*
6" x 10" (15 x 25 cm)
Arches Hot Press Watercolor Paper, White

I got the idea for this work during the ice storm of 1998, which was one of North America's worst winter storms of the century. It wrecked havoc, toppling millions of trees, hydro towers, and power lines and left entire communities without electricity and water for several weeks in record-low temperatures. Visually, everything was an ice-covered wonderland. The ice had enclosed the leaves and buds, which looked quite surreal. I knew I had to capture this beauty on paper.

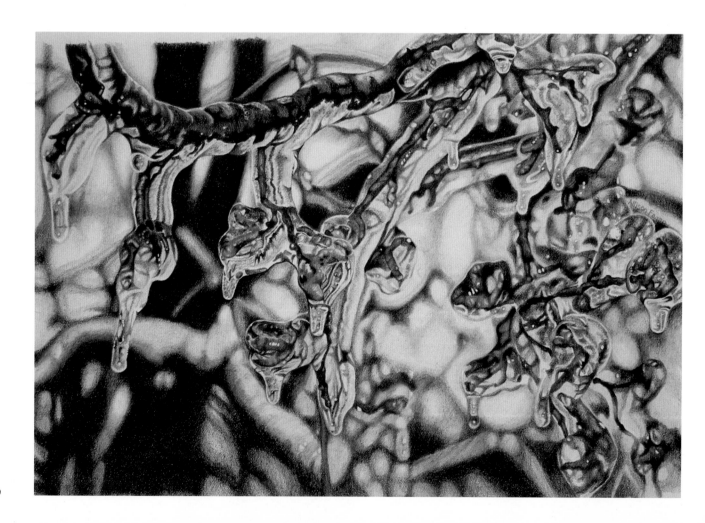

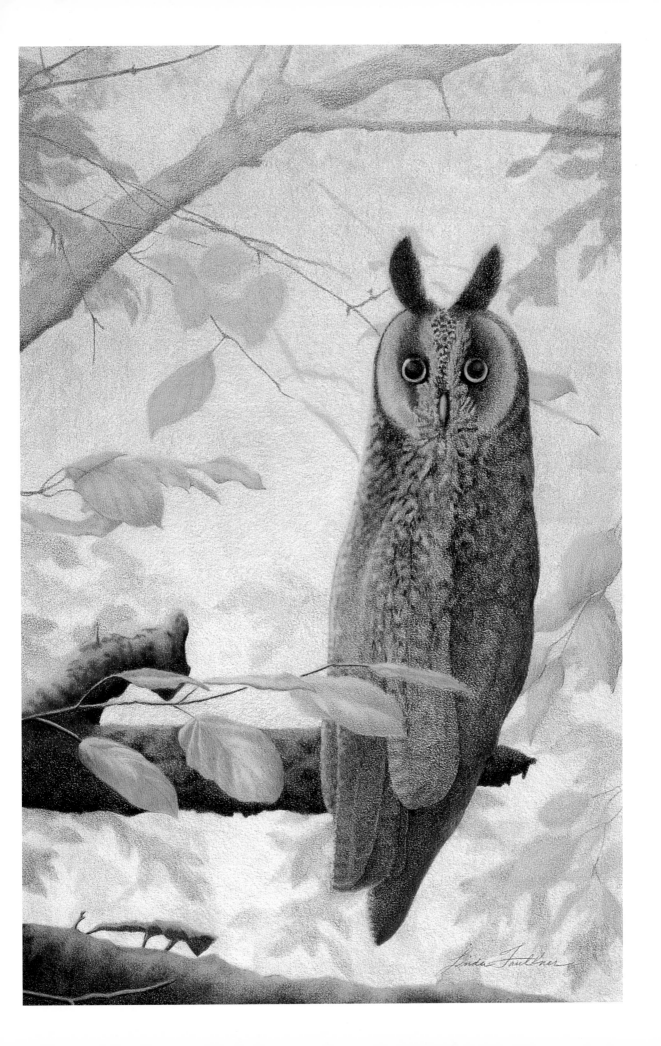

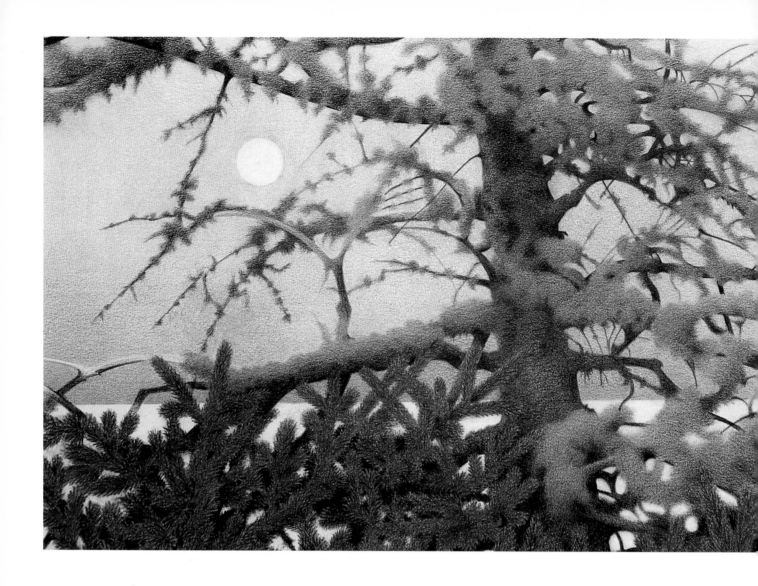

**MARILYNN H. MALLORY**

*Moonrise: Scoville Point*

18" x 24" (46 x 61 cm)

Lanaquarelle Cold Press Watercolor Paper, White

My work celebrates the American wilderness. An avid outdoorswoman, I find inspiration for my paintings in the patterns of sticks, rocks, and leaves at my feet as well as in more spectacular woodland, mountain, and desert vistas. Recently, I spent two weeks as artist-in-residence in a remote rustic cabin on Isle Royale, a national park surrounded by Lake Superior. There was no running water or electricity. I rose with the sun and went to bed with the moon. The isolation of this pristine wilderness of conifers, inland lakes, glacier-carved rocks, and animals such as moose, wolves, foxes, and loons provided a wonderful environment for tuning into the rhythms of nature that inspire my art.

## TERESA McNEIL MacLEAN

*Baxter Pass #4 (Sierra Nevada)*

9" x 12" (23 x 30 cm)

Strathmore 300 Bristol Board, White

Baxter Pass is a 12,000 foot-high, Sierra Nevada pass with an ungroomed trail leading to its snowy and rocky summit. When we reached the pass, black clouds boiled up, and lightning became a concern. I quickly took color notes and lots of photos. Back in my studio, I began by taping a collage of my photos to the drawing table, along with my color notes and four bristol boards. When a gentleman saw the completed work, he said that this piece made him dizzy. He felt like he was going to fall into the vortex at the left. I took that as a compliment since that was exactly how I had felt when I was standing there.

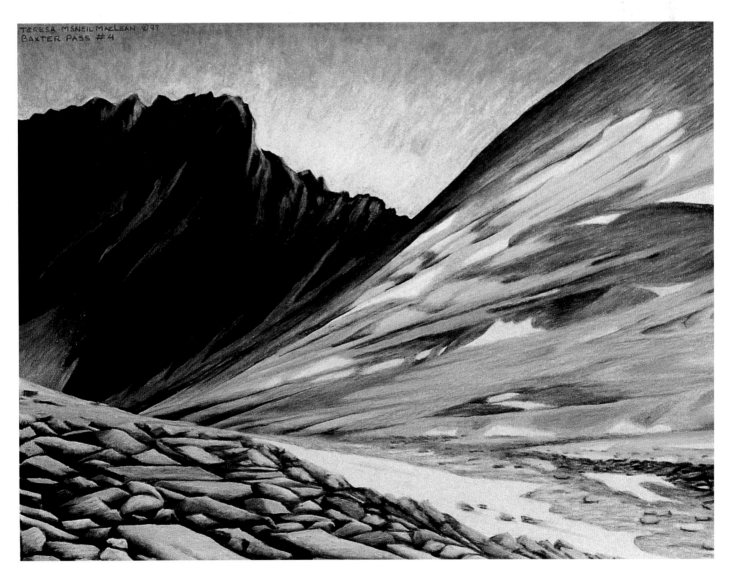

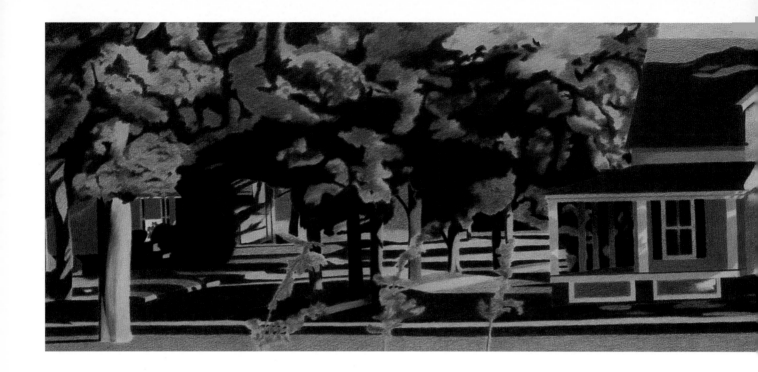

**JODY BEIGHLEY**

*Place Of Passage*

10" x 32" (25 x 81 cm)

Strathmore 4-Ply Museum Board, White

In the right light, man-made structures can seem to grow organically along with the trees, coexisting in perfect harmony. I'm motivated to do scenes that combine nature's elements with man's better architectural efforts. Perhaps this is my unconscious metaphor for environmental awareness. My reaction to the bland, sterile subdivisions being built around me is to visually preserve the places that have idiosyncrasies and character through my art. I also respond to light and its effect on color. Certain times of day take on an unreal, almost mystical quality. At times like these, the ordinary becomes extraordinary when one stops to notice.

**DARRYL D ALELLO, CPSA**

*Nature Unraveled*

13" x 17" (33 x 43 cm)

Strathmore 4-Ply Museum Board, White

I saw this intriguing palm tree while visiting the San Diego Zoo. The warm sun cast the most fascinating light that danced across the palm fronds. As the fronds crossed each other to reach toward the sky or peep through the shadows, they formed very interesting negative shapes. I painted this subject using colors Mother Nature dare not use. I call this particular style "contemporary realism."

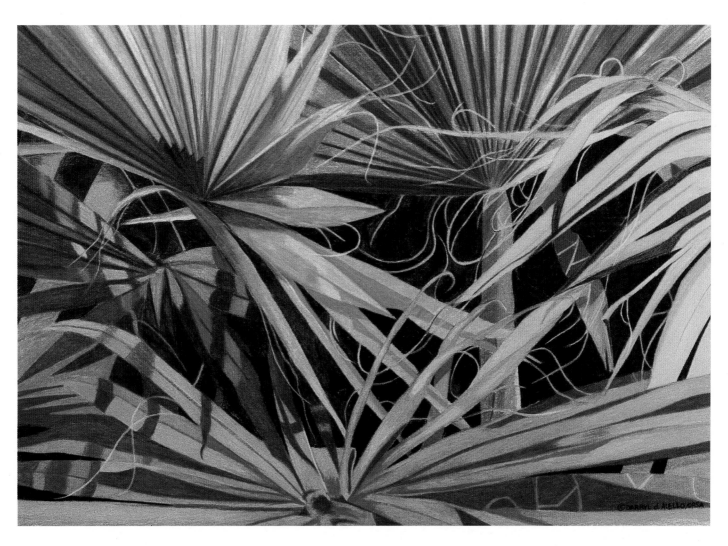

## STEPHEN DEMPSEY

*Tillicious*

25" x 29" (64 x 74 cm)
Canson Mi-Tientes, Cream

The stroke of a colored pencil on paper is much more personal and determined than the stroke of a brush on canvas. I create a new look by painting subjects, real or imagined, with non-traditional colors. While I retain realism in my work, I choose contrasting colors to portray the subject in an artistic way. For example, everyone can visualize a jaguar, but can you imagine a beautiful green jaguar blending in with its natural surroundings like a chameleon? This approach adds a visual energy that forces the onlooker to view my paintings in a different perspective.

## ELYSE WOLF

*Bowl Of Fruit*

31" x 38" (79 x 97 cm)
Crescent 4-Ply Mat Board, White

In setting up this still life, I was inspired by Japanese art, with its asymmetry and cropped views. The color scheme is one I've often seen in the posters and commercial art of the 1930's, and it has always appealed to me. I used 40 or 50 different colors to achieve it. For me, the hardest part of any picture is arranging the still life and making the initial sketch. Since still life is a relatively static genre, I concentrated on developing a feeling of tension and dynamism through the placement of shapes and colors. This allows the viewer's eye to move easily across the surface. Blending the shadows evenly over such a large area proved harder than I expected and took longer than any other part of the painting.

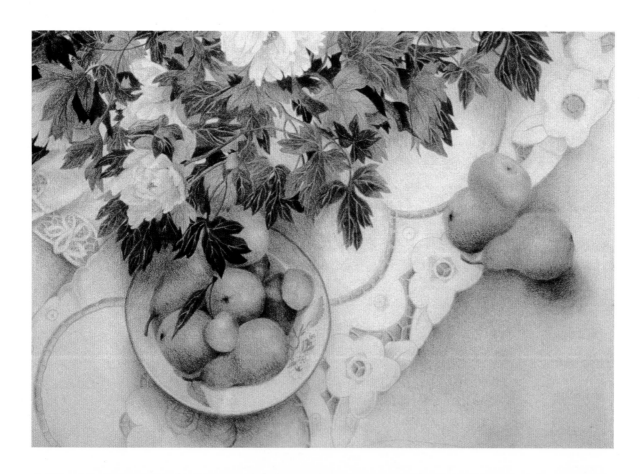

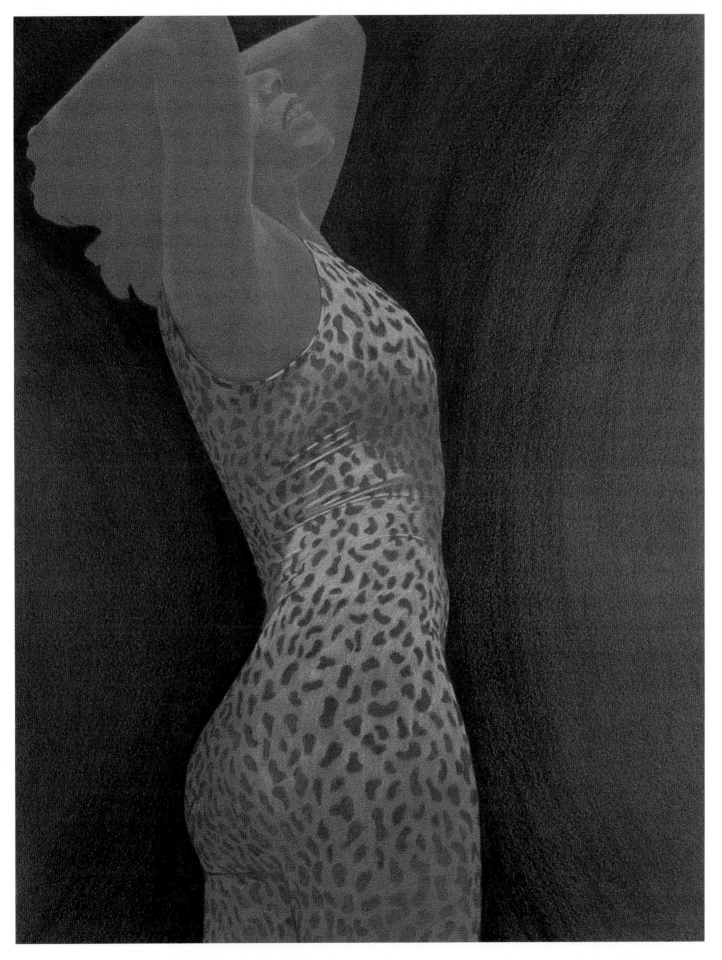

**MARJORIE SPALDING HORNE**

*Cades Cove Rhododendron*

20" x 16" (51 x 41 cm)

Crescent 100 Illustration Board, White

Colored pencils have been my primary medium for almost twenty years, so I have tried many techniques. I began this drawing with an underpainting of layers and went on to incorporate art sticks, solvent, impressed line, cross-hatching, and burnishing into the process. While I generally strive to achieve a muted effect in my artwork, I often use a multitude of more brilliant hues to create greater richness and depth. I seldom use grays, almost never use black, and still do all of my drawing freehand. If my image is not exactly like the source material, than that's just part of my "signature." My hand translates what my eyes behold.

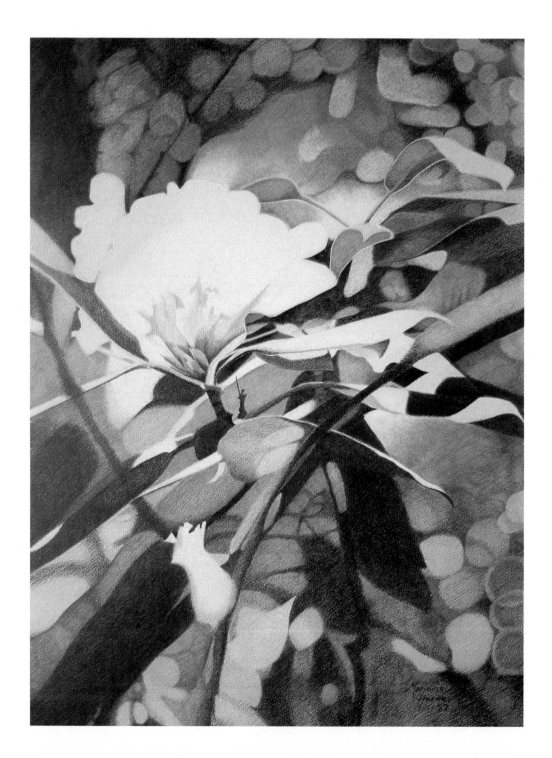

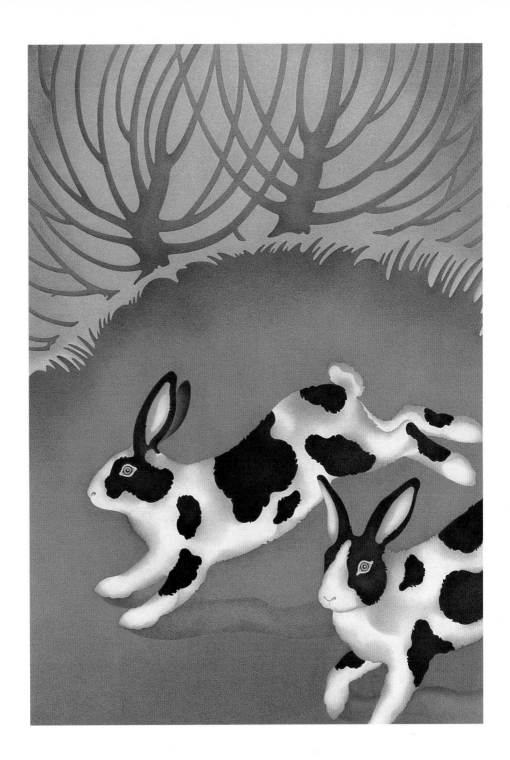

**DANI HENNESSY**

*Ida's Dream*

17" x 12" (43 x 30 cm)

Arches Hot Press Watercolor Paper, White

*Ida's Dream* emerged while watching our standard poodle, Ida, sleeping. As she lay "running" and barking, in her R.E.M.-state of dreaming, I tried to imagine what my dog would possible dream about and whether she could form a mental image of something not wholly perceived in reality. Since dogs, like children, have an unquestioning exuberance for life, I stylized this painting to depict this childlike (doglike) dream experience. For an illustrative effect, I chose a simple color field and some surreal elements. This work is representative of my love for creating shapes and movement—representational, but not real, in color, form, and composition.

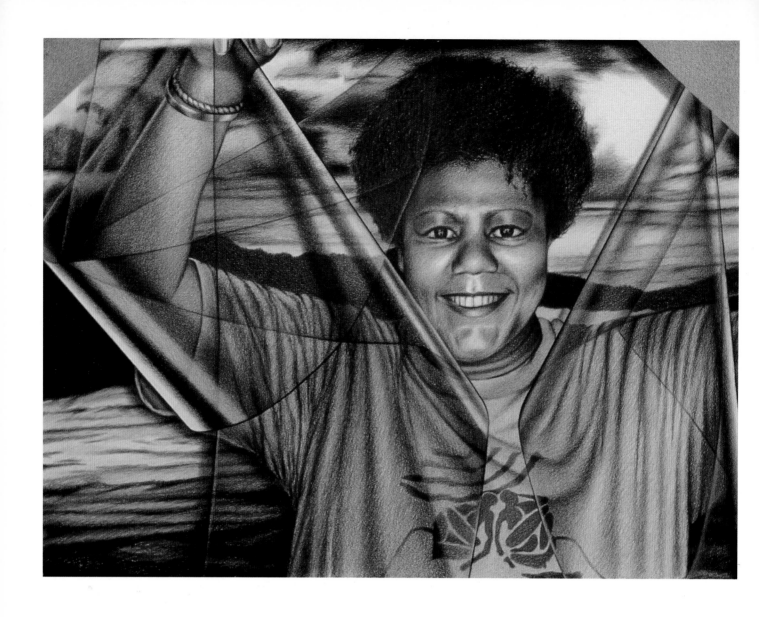

**LULA MAE BLOCTON, CPSA**

*Ribbon Self-Portrait*

22" x 30" (56 x 76 cm)
BFK Rives Paper

When I view an artwork, I am always curious about what the artist who
created it looks like. So, a few years ago, I began a series of self-portraits.
Rembrandt influenced my approach to this subject, "with his repeated
analysis of character and psyche over the span of a lifetime." This painting
is the first of six. All of them approach my face frontally. I never show my
legs, although sometimes I show my arms and hands. I include objects I care
about, such as a piece of twisted transparency used in my drawings, my
bracelets, a favorite T-shirt, a copy of a special person's artwork, etc. This
series represents the documentation of my environment and myself through
the use of visual symbols.

## GAIL PIAZZA

*Grieving*

20" x 18" (51 x 45 cm)
Strathmore Bristol Vellum 200, White

When I was a child, my mother spent hours drawing wonderful pictures to accompany the fascinating stories she would tell me. Now, as a children's book illustrator, I am still motivated by the written word. *Grieving* was a result of a series of books, by poet Lucille Clifton, about the trials and tribulations of a boy named Everett Anderson. In this particular piece, the boy's father had died. For this work, my model was a little boy from my daughter's school whose mother allowed me to take pictures in their home. This has become one of my favorite pieces, and I relate to the drawing even more now that I, too, have lost my father. Grief is a universal emotion.

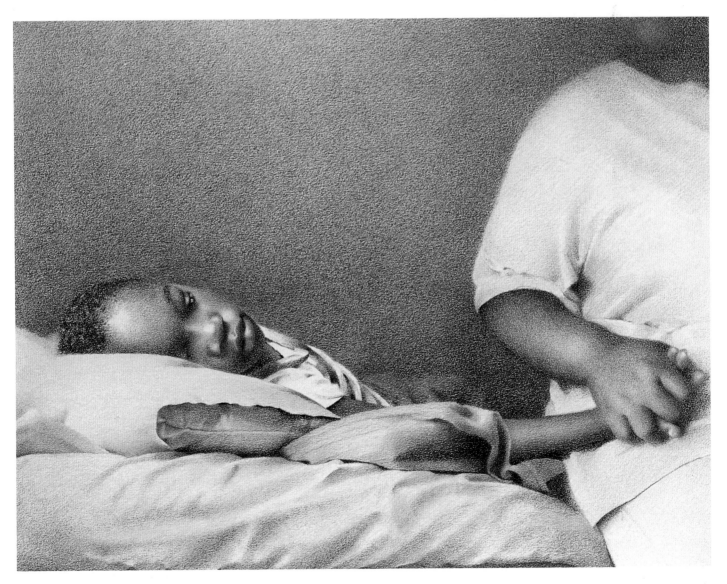

**SUSAN MORTENSON**

*Marsh*

9" x 8" (23 x 20 cm)

Strathmore 500 Bristol Board, White

We live on a small island called Enchanted Island, where my husband and I enjoy boating, biking, and walking, especially in the evenings. One night I took photographs of the setting sun pouring in through the reeds. Unfortunately, I misplaced these pictures. But it didn't matter. After six "Marsh" drawings, I finally created the one that captured the scene as I remembered it that evening.

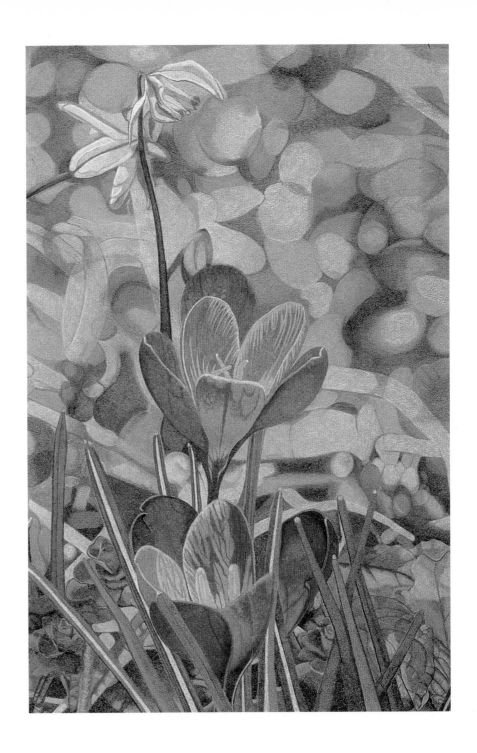

## CAROLYN J. HAAS

*Crocus*

10" x 7" (25 x 18 cm)

Canson Mi-Tientes, Sand

I am constantly thinking about the next precious chance to sit down with my art. Most everything I encounter, even briefly, is visualized as a possible subject for canvas or paper. My yard is abundant in subject material. The crocus is the first flower to appear in spring, even if it needs to push through snow to do so. Ah, spring! A time for new beginnings! Everything that lay dormant comes to life again, including my creativity. Communicating with my talented sister on an almost daily basis also helps my creativity. The constant progress reports over coffee have become a very important part of my day. I am fortunate to have someone so near with which to share the frustrations and triumphs.

## PROCTOR P. TAYLOR

*Space Warp III*

14" x 11" (36 x 28 cm)
Strathmore 2-Ply Bristol, White

Fascinated by the geometric possibilities of the Mobius strip, I constructed one using wet bristol paper. By shaping it in "knots," I made a wonderful discovery: The Mobius strip presented a complex, difficult-to-imagine set of movements. Because this artwork is done from imagination and contains visual contradictions, I intentionally violated traditional lighting in order to heighten my subject's unworldly appearance. I started this project because of my interest in the Mobius strip. It has only one side, and only one edge. It is simple, ingenious, and practical. In this artwork, perhaps I have also shown that its application can be aesthetic, graphic, and spatial!

## MIKE PEASE, CPSA

*Ashland Farm*

24" x 36" (61 x 92 cm)
Strathmore 2-Ply Museum Board, White

I am an explorer at heart, a hunter of hidden treasure. The treasures I seek are special places, ones that remind me that it is possible for people to live in harmony with nature. We can make buildings, roads, and fences—even altering the land itself—while preserving nature's beauty. I go to great pains to avoid paintings that seem to be about a particular place, and this image is not about this particular farm. It's about living with respect for land, animals, sky, and plants. The residents of this farm had little concern for their "earth connections." One of my great pleasures in art is to be able to remove the human misuse of the land to reveal its basic beauty, which is obviously, a romantic viewpoint on my part.

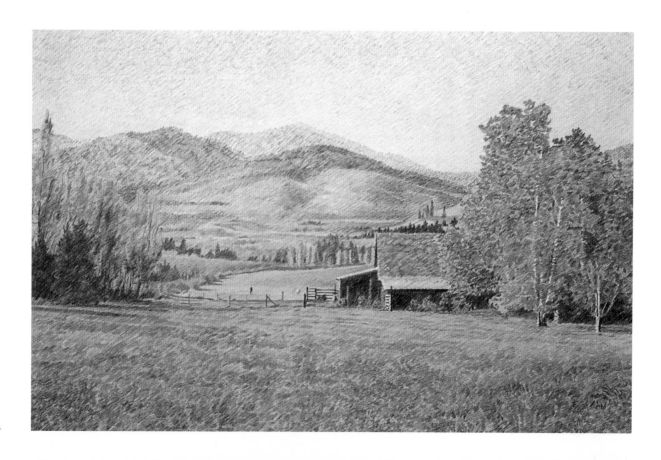

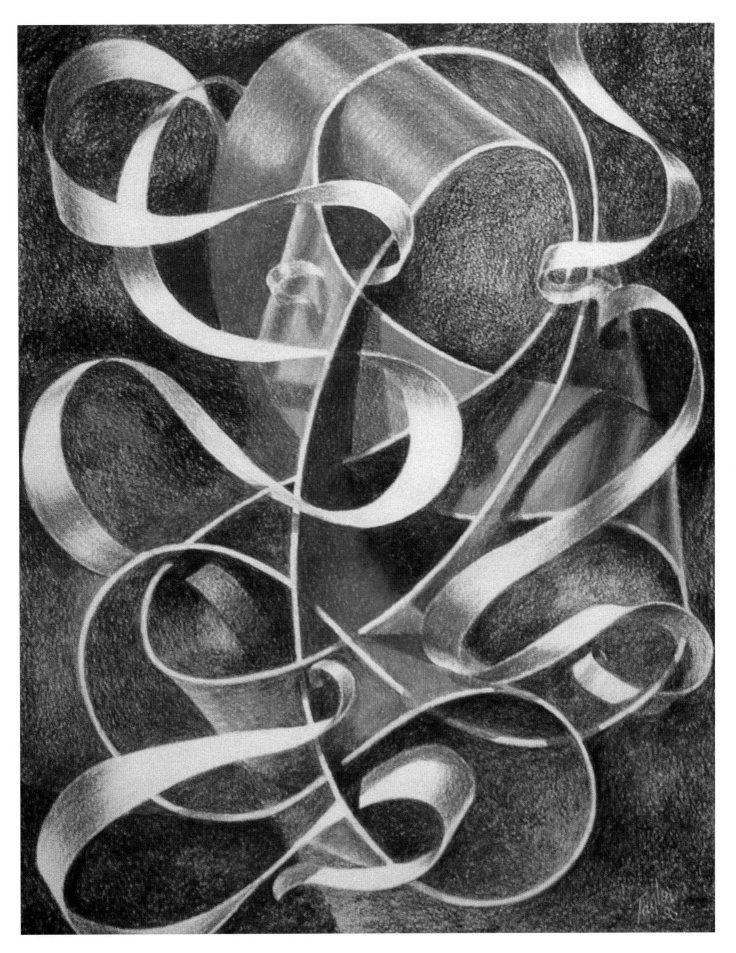

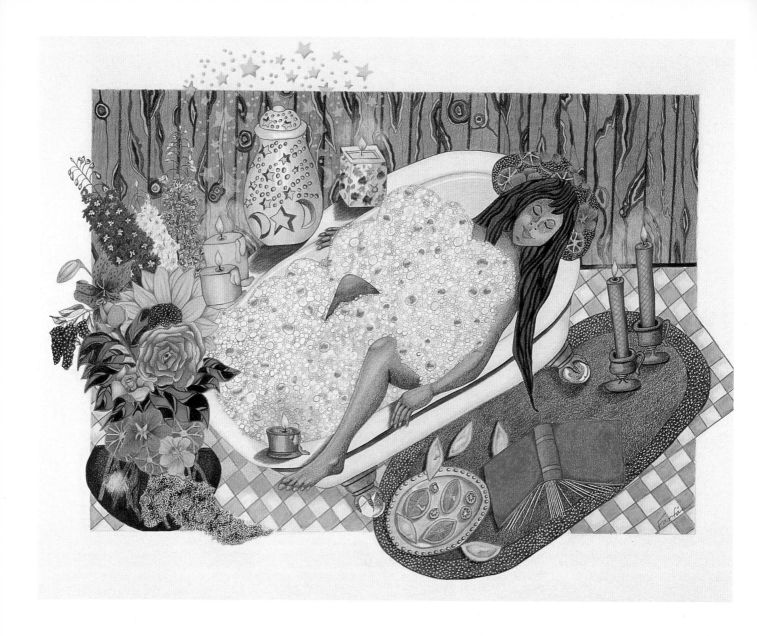

**RHONDA FARFAN**

*The Bubble Bath*

20" x 26" (51 x 66 cm)

Rising Gallery 100 Paper, White

My work originates from an internal source rather than external reference materials such as photographs, still-life setups, or visual landscapes. To me, the concept is the goal, and technique is merely a means of conveying my ideas. This piece is one of a series of paintings based on how women relax. In talking with other women, I was astonished to find that most women don't relax. I decided to explore this concept of what women do when they finally take time for themselves. Of all the women I spoke to, the bubble bath was the most preferred form of relaxation. This series is a whimsical attempt to convey a sense of peace, a short respite from our all too busy lives and a break from the chaos.

## KAY M. DEWAR

*The Column*

12" x 9" (30 x 23 cm)

Fabriano Uno, White

Architectural subjects, particularly the ornamental portions of buildings, attract my attention. I am also intrigued with the possibilities presented by a limited palette. Including color in an image while still maintaining an overall black-and-white feel is just a matter of taking the grisaille method a few steps further. The challenge is to add just enough color to increase the illusion of depth and yet leave the impression of a monotone image. This decorative column drenched in sunlight was perfect for this concept and immediately called out to me, "paint me!"

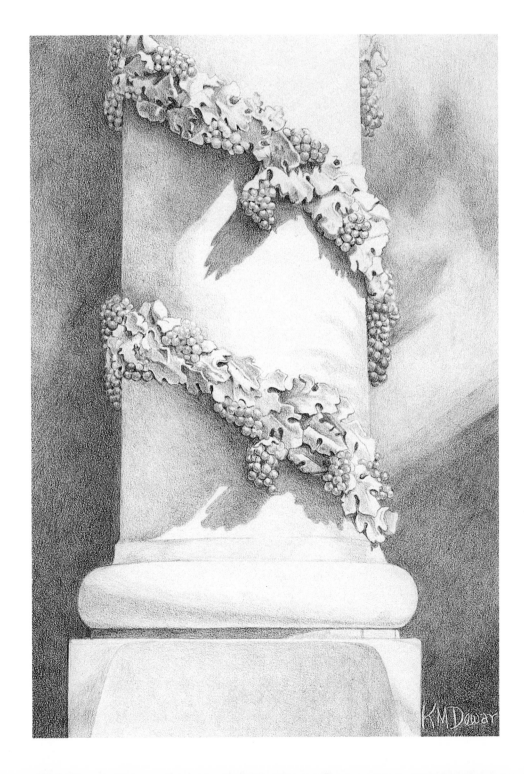

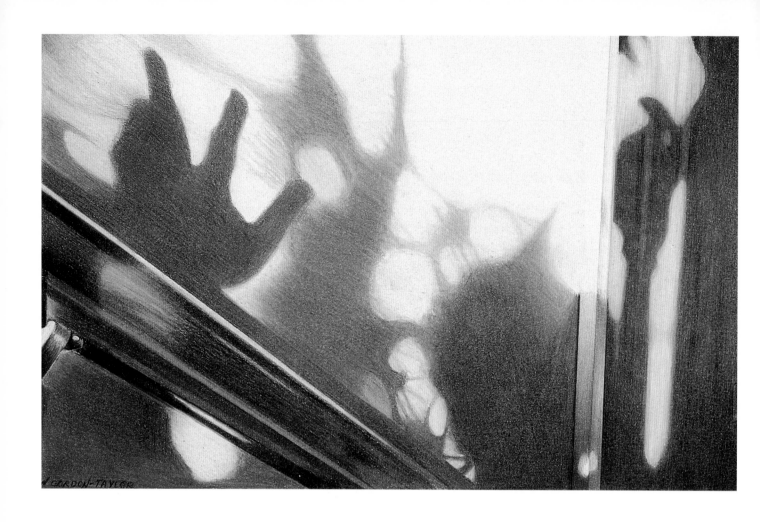

## NADINE GORDON-TAYLOR

*Erebus Rejected*

7" x 9" (18 x 23 cm)
Strathmore Bristol, White

My images have always dealt with the human form. Currently, it is the
absence of that form that intrigues me. This painting, which is part of a
series entitled "Self Portrait Minus Self," is one of many that focuses on my
shadow and domestic spaces. As a child, I was aware of spaces that were
inaccessible due to their locations or their psychological overtones. Stairs to
another level or doors to another space have often appeared in my work.
This piece illustrates my horned shadow moving down the staircase wall to
my closed studio door. The shadow of the banister looms over the door as if
it were a gate denying my admittance to the underworld of art. As Jung once
stated, "the ego and shadow come from the same source and exactly balance
each other. To make light is to make shadow; one cannot exist without the
other."

**CARLYNNE HERSHBERGER**

*On The Lookout*

18" x 24" (46 x 61 cm)

Canson Mi-Tientes, Tobacco

My work is changing. It's coming from a different place, a more intuitive place. I want it to express my connection to the world more than a literal representation of it. This painting originated while my husband and I visited a state preserve near our town. As I looked over the railing, I saw our shadows in the long straw-colored grasses of the prairie. They looked so mysterious and strange. That feeling of mystery is what I wanted to retain more than anything else. The figures were the two of us, yet they could be anyone. A portrait with no identity.

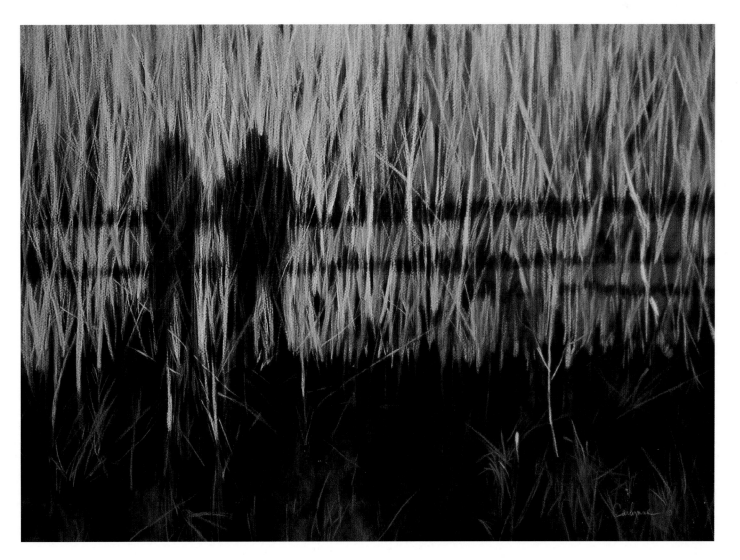

## Bernard A. Poulin

*My First Self-Portrait*

28" x 20" (71 x 51 cm)
Canson Mi-Tientes

*My First Self-Portrait* is evocative of that time when we discover ourselves as individuals, separate from others in some mysterious way. We realize we're a unique, functioning entity. It recalls those earliest days when we were unabashedly sketchers and painters of everything that met our intense gazes. It also reminds us of how important we all thought we were and of how easy it was to impress those significant adults who doted upon our every brushstroke. This work especially notes the great need we all have to "exhibit ourselves" before the wondrous eyes of those we deem worthy of our submissions and who are unconditionally generous in their recognition of our "genius."

## Lee Sims

*Scootchers*

12" x 23" (30 x 58 cm)
Dulcet Paper 80 lb. Text, White

Beginning with the escapist doodles I did in grade school to the endless pages of horse drawings I did later on, art has been a place of controlled refuge where I recorded my thoughts, anxieties, and dreams. This work is reminiscent of my early formal art education. Abstraction had a very strong influence on me; and even today, I frequently return with pleasure to its challenges and goals of manipulating forms into compositional entities. Disposable packaging materials become animated objects that seem to be engaged in an unspecified drama. The name "Scootchers" (Scottish for "mischief-makers") describes the spirit of hooliganism present. Something is afoot here. It's up to the viewer to interpret what.

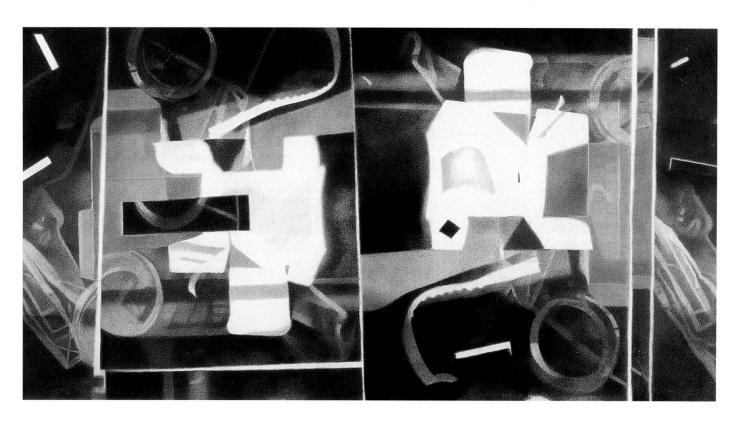

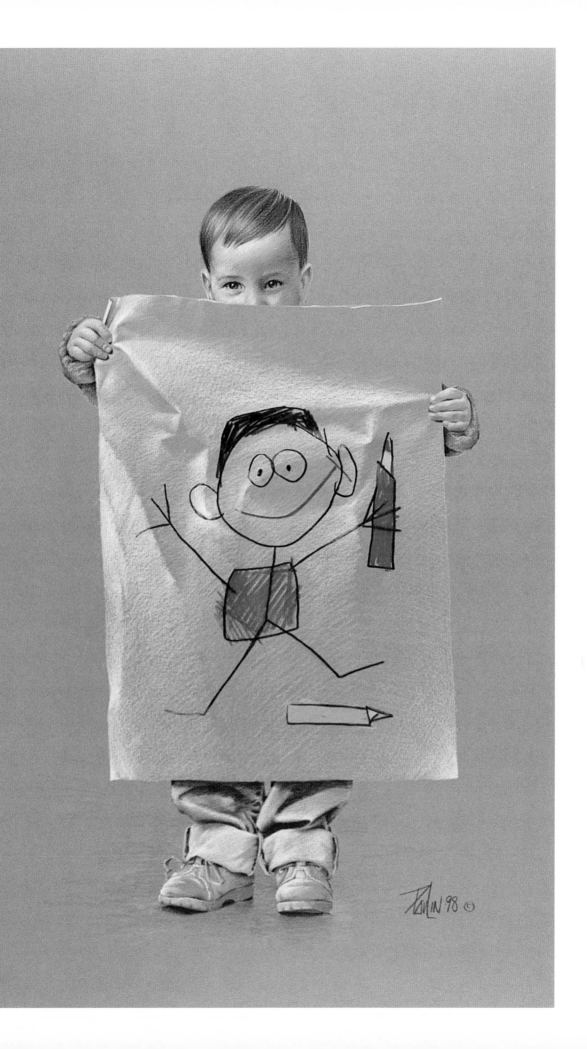

**TANYA TEWELL**

*She's A Strange Child*

17" x 26" (43 x 66 cm)

Fabrianno 140 lb. Hot Press, White

My daughter has always been a very imaginative and spirited person who believes in the power of magic in our lives. Growing up in Arizona, she learned a great deal about Native American beliefs and religious practices. Because of our friendship with a powerful, elderly medicine woman, we both learned first-hand about the Navajos and their concept of Skinwalkers, people (usually witches) that can change from an animal or human shape at will. As I observed the rapid, amazing, and sometimes frustrating transitions in my daughter's physical and psychic transformation from late childhood to early adolescents, she seemed to embody this Navajo concept. The figure's proportions in this work show a child's head and neck, while the rest of the body is the size of an adult. I think this is a very vulnerable time in a female's life.

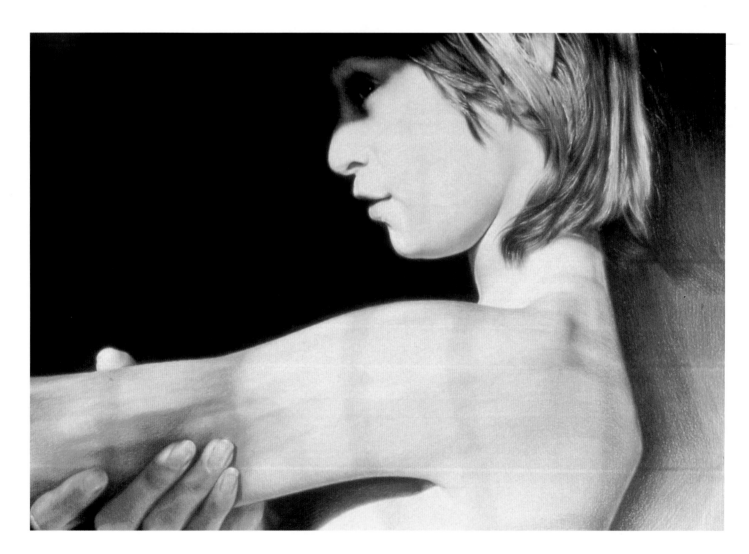

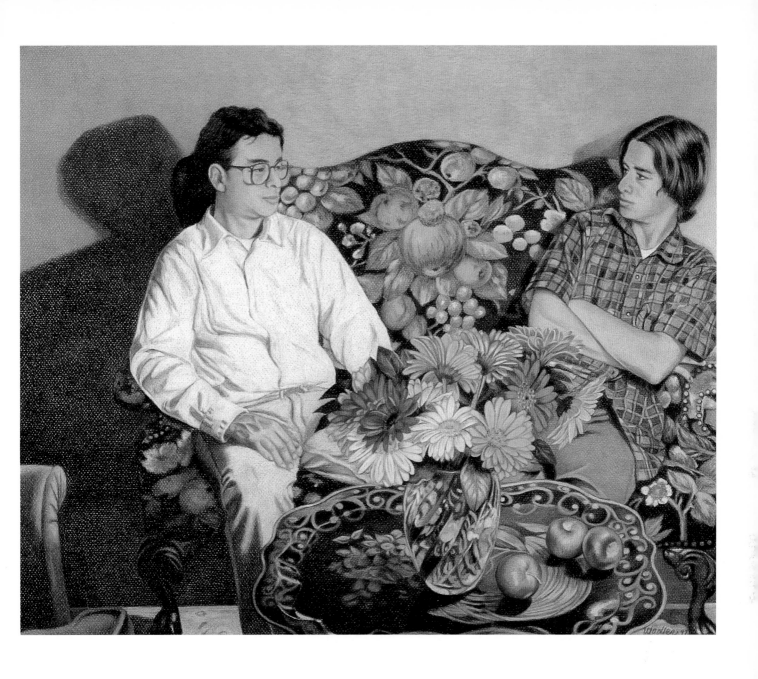

## RONNI WADLER

*Still Life With College Talk*

20" x 24" (51 x 61 cm)

Canson Mi-Tientes, Light Brown

When working with figures, I have always enjoyed the endless opportunities to delve into the psychology of the people I sketch from. Often, there is a story unfolding. However, I always expect viewers to decide for themselves what the activities of the subjects imply. The use of still life in this series is a foil to counter the complexity of the figures and to purposely lead the viewer's eye to a specific part of the composition. This piece was inspired by the interaction between my son and my husband as they explored college options. My intent was to capture the body language and facial expressions of the two as they discussed this sensitive subject.

**CONNIE COLE-CRAVEN**

*Remembering The Sorrow*

16" x 12" (41 x 30 cm)
Strathmore 4-Ply, White

In the last two years of my life I have experienced a number of changes
and some sadness. I wanted to convey the loneliness and solitude I felt
during this difficult and dark time. The idea of the chair with its back to the
viewer seemed appropriate because so often I just wanted to turn my back
to everyone. I felt so alone. All the words that would describe this room—
bleak, desolate, and empty—are also the words that described my feelings.
A professor once told me to paint my personal landscape, my surroundings.
Since I have moved a number of times in recent years, I seemed to be in a
continual state of saying "where should I put this chair, this couch, this table."
Thus, the choice of a chair to represent my feelings was an instinctive one.

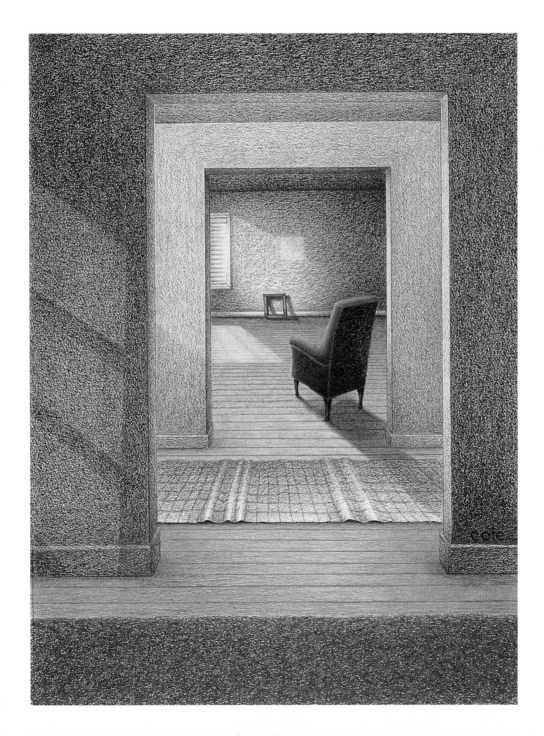

# GLOSSARY

**Analogous Color Scheme:** Using the shades, tints, or tones of any three colors that are next to each other on the color wheel.

**Background:** The part of the composition that appears to be farthest from the viewer.

**Bristol Board:** A stiff, durable cardboard made in plate and vellum finishes with thicknesses of one- to four-plies.

**Burnish:** A technique of smoothing and blending layers of pigment that obliterates the paper's surface and leaves a glossy finish. May be done with a tortillon, burnishing tool, or a light-hued colored pencil.

**Chiaroscuro** (ke-AR-o-sk/y/oor-o): Creating the illusion of form and volume on a two-dimensional surface through the use and distribution of pronounced lights and darks. Classic precepts call for only one source of light.

**Cold Press Paper:** This refers to the medium-rough texture of the paper as a result of being pressed with cold weights during processing.

**Collage:** The process of constructing flat (or low-relief) two-dimensional art by gluing various materials (i.e., newspaper, photographs, etc.) onto the painting surface.

**Colorless Blender:** An alcohol-based, felt-tipped marker containing no color pigment. The clear solvent is used over one or more layers of dry pigment to produce a smooth, painted finish.

**Complementary Colors:** Any two colors that are opposite each other on the color wheel (i.e., red and green). These colors create a high contrast when placed side by side.

**Contrast:** The juxtaposition of extremes—as in colors (purple with orange), values (white with black), textures (coarse with smooth), etc.—within the composition.

**Contour Drawing:** Lines drawn to relate the edge of volume in an object.

**Crosshatch:** Colored pencil strokes applied at right angles to each other to create contrasting tone and density.

**Drawing:** A term applied to the dominance of lines as a means of defining shapes and forms.

**Figurative:** Any image that represents the human form as a figure, symbol, or likeness.

**Fixative:** A thin liquid of resinous solvent sprayed over colored pencil artwork to protect it from smudging and to eliminate wax bloom. It is available in workable, matte, and glossy finishes.

**Focal Point:** The center of interest or activity within a composition.

**Foreground:** The area of a painting that is nearest to the spectator.

**Frisk™ Film:** A brand of clear film backed with a low-tack, removable adhesive. It is commonly used to protect unfinished areas of a painting, but it is also used to remove, or lift, pigment from the surface.

**Frottage:** A technique of transferring the texture of a surface (such as wood, stone, etc.) by rubbing pigment on paper that has been placed over it.

**Gradation:** A fine progression of values. Also, the imperceptible blending of adjacent colors.

**Graphite Paper:** A thin paper coated with graphite used for transferring drawings done on tracing paper onto the art paper.

**Grisaille** (gree-sigh): A monochrome painting modeled in shades of gray. Commonly used as a base coat before applying colored pigments.

**Hatching:** Strokes of diagonal lines placed parallel to each other.

**Hot Press Paper:** This refers to the smooth surface of the paper as a result of pressing it between calendar rollers that flatten the grain into an even finish.

**Hue:** The actual color of anything. Also used to describe what direction a color leans toward (i.e. bluish green).

**Illustration Board:** Layers of paper adhered to a cardboard backing to produce a sturdy drawing surface. It is made in various thicknesses and textures.

**Impressed Line:** A technique of using a blunt instrument, such as a stylus, to etch lines into the surface of the paper. Color can then be added tonally while retaining the impression.

**Key:** Refers to the range of color values in a painting. High key work is dominated by light, bright, or pale colors. Low key work is dark and subdued.

**Local Color:** The true color of an object seen in ordinary daylight.

**Museum Board:** Available in two- and four-ply, this soft, textured surface absorbs wet or dry pigment readily.

**Painting:** A term applied to forms that are defined by the juxtaposition of color and values rather than lines.

**Pencil Extender:** An instrument that holds a pencil stub for longer use.

**Pointillism:** The technique of composing an entire image through the use of small dots of color.

**Saturation:** The intensity or brightness of a color.

**Scumble:** A light coating of a pigment rubbed or smeared over the painting to make it softer and less linear.

**Sgraffito** (skra-fee-toe): The method of creating designs by scraping the top layers of pigment to reveal the different colors of the underlying layers.

**Stipple:** To create an optical mix of colors through the use of dots or dashes.

**Tonal Application:** A coat of color finely applied with strokes or circles so that no linear marks are left visible.

**Tooth:** Refers to the depth of the grain of the paper.

**Tortillon:** Tightly rolled gray or white paper used for blending colors, also referred to as a "stump."

**Value:** The relative lightness or darkness of a color.

**Vellum:** A smooth cream-colored paper resembling calfskin.

**Wax Bloom:** Occurs when the concentration of wax in the layers of pigment rise to the top to create a "fog" that dulls and subdues colors. This usually happens when using heavy pressure on several layers, as in burnishing, and can be easily eliminated with light layers of fixative.

# DIRECTORY OF ARTISTS

Darryl d Alello, CPSA
218 Tate Rd.
Denham Springs, LA 70726

Bonnie Auten, CPSA
213 E. Chicago Blvd.
Tecumseh, MI 49286

Pat Averill, CPSA
14137 Conway Dr.
Oregon City, OR 97045

Gary E. Bachers
101 South Maple St.
New Boston, TX 75570

Carol Baker, CPSA
32661 Pearl Dr.
Fort Bragg, CA 95437

Joe Bascom, CPSA
1550 York Ave.
New York, NY 10028

Donna Basile, CPSA
P.O. Box 97
Scituate, MA 02066

Elaine Bassett
32601 76th Ave. NW
Stanwood, WA 98292-9729

Suzanne Bauman
P.O. Box 250027
Franklin, MI 48015-0027

Jody Beighley
411 Arnold St.
Rothschild, Wl 54474

Pamela Belcher
6824 NE 160th St.
Bothell, WA 98011-4215

Sandra Benny
4 Lloyd Lane
Huntington, NY 11743

William A Berry
908 Edgewood
Columbia, MO 65203

Lula Mae Blocton, CPSA
P. 0. Box 2
Hampton, CT 06247

Susan L. Brooks, CPSA
5668 Southern Hills Dr.
Frisco, TX 75034

Phil Brulia
504 N. Marian St.
Ebensburg, PA 15931

E. Michael Burrows
PO Box 340
Cordova, NM 87523

Lynn A. Byrem, CPSA
324 North Nyes Rd.
Harrisburg, PA 17112

Donna Caputo
1503 Aquino Lane
Lady Lake, FL 32159

Connie Cole-Craven
1864 N. Longridge Pl.
Eagle, ID 83616

Gail T. Collier, CPSA
788 Golf Ct.
Barrington, IL 60010

Kathryn Conwell
809 NW 41
Lawton, OK 73505

Cira Cosentino, CPSA
2277 SW Olympic Club
Terrace
Palm City, FL 34990

Vera Curnow, CPSA
Vera Curnow Gallery
215 Main St.
Rising Sun, IN 47040

Luanne D'Amico, CPSA
19306 NW 81st Terrace
Alachua, FL 32615

Denise Danielsson
2626 Briarcliff Ave.
Cincinnati, OH 45212

Dr. Christine J. Davis, CPSA
1071 River Rd.
Greer, SC 29651-8197

Martha DeHaven, CPSA
106 La Vista Dr.
Los Alamos, NM 87544

Stephen Dempsey
6218 Laura Lane
Tinley Park, IL 60477

Kay M. Dewar
Bremerton, WA

Sheri Lynn Boyer Doty, CPSA
4540 S. 2995 East
Salt Lake City UT 84117

Kathleen Dunphy
P.O. Box 868
Ocean View, DE 19970

Alllison Fagan, CPSA
Allison Fagan Visuals
40 Drainie Dr.
Kanata, Ontario K2L3J9
CAN

Rhonda Farfan
25318 Ferguson Road
Junction City, OR 97448

Linda Faulkner
PO Box 371
Greentown, OH 44630

Laura Fisher
14 Serene Creek Place
The Woodlands, TX 77382

Kathleen Flannigan
The Kathleen Flannigan
Gallery
1801 University Ave. #206
Berkeley, CA 94703

Susan Lane Gardner
17990 SW Hart Dr.
Beaverton, OR 97007

Donna Gaylord, CPSA
Nature's Tracks
1980 W Ashbrook Dr.
Tucson, AZ 85704

Janie Gildow, CPSA
R.T. Pencils Studio
905 Copperfield Lane
Tipp City, OH 45371

Nadine Gordon-Taylor
82 Eleanor Dr.
Mahopac, NY 10541

Marilyn Gorman
Marilyn Gorman Studios
739 Lakeview
Birmingham, MI 48009

Robert Guthrie, CPSA
3 Copra Lane
Pacific Palisades, CA 90272

Susan D. Gutting
110 W Main St.
Kendrick, ID 83537

Carolyn J. Haas
345 Avon Dr.
Pittsburgh, PA 15228

Daniel Hanequand
10 Huntley St. #505
Toronto, Ontario M4Y 2K7

Pennye L. Hanky
14599 Clazemont Rd.
Montpelier, VA 23192

Cathy Heller
13003 Montpelier Ct.
Woodbridge, VA 22192

Dani Hennessy
7305 Galpin Blvd
Excelsior, MN 55331

Edna L. Henry, CPSA
11992 SW Royalty Ct. #20
Portland, OR 97224

Barbara Herkert
1105 SE 1st St.
Newport, OR 97365

Carlynne Hershberger,
CPSA
1016 NE 3rd St.
Ocala, FL 34470

Priscilla Heussner, CPSA
916 Whitewater Ave.
Ft. Atkinson, WI 53538

Sylvester Hickmon, Jr.
126 Milton Rd.
Sumter, SC 29150

Elizabeth Holster, CPSA
727 East 'A' St.
Iron Mountain, MI 49801

Marjorie Spalding Horne
505 Forest Hills Rd.
Knoxville, TN 37919

Glenn L. Houseman
1 Lafayette Pl. Apt. #2014
Detroit, MI 48207

Richard Huck, CPSA
615 W. Marion St.
Lancaster, PA 17603

Priscilla Humay
P. 0. Box 148
Gurnee, IL 60031

Suzanne Hunter, CPSA
6752 Fiesta Dr.
El Paso, TX 79912

Vivian Mallette Hutchins
517 N. Tanque Verde Loop
Tucson, AZ 85748

Warren J. Ingalls
Ingalls Art
10585 Merlot Ct.
Alta Loma, CA 91737

J. Corinne Jarrett
1316 SE Condor Place
Gresham, OR 97080

Helen Jennings
1213 W. Cheyenne Dr.
Chandler, AZ 85224

Carol Joumaa
3706 Prince William Dr.
Fairfax, VA 22031

Jill Kline, CPSA
Marquette, MI 49855

Kristy A. Kutch
11555 W. Earl Rd.
Michigan City, IN 46360

Chris LaMarche
1118 N. Fairlawn Ave.
Evansville, IN 47711-5320

Donna Leavitt
22415 85th Ave. W.
Edmonds, WA 98026

Teresa McNeil MacLean
P.O. Box 1091
Santa Ynez, CA 93460

Linda Mahoney
5 Encino Loma
Beeville, TX 78102

Marilynn H. Mallory
Decatur, GA 30033

Karla Mann
3300 Brookbridge Rd.
Virginia Beach, VA 23452

Susan Mart
1901 N Dayton
Chicago, IL 60614

James K. Mateer, CPSA
218 Wenner St.
Wellington, OH 44090

Ruth Schwarz McDonald
Box 252
Philipsburg, MT 59858

Katherine McKay
P.O. Box 5472
Richmond, CA 94805

Gail McLain
43 Bluegrass Lane
Sequim, WA 98382

Gail E. Mercer
4867 Manchester Rd.
Akron, OH 44319

Susan Mortenson
3944 Enchanted Lane
Mound, MN 55364

Kimberly Mullarkey, CPSA
468 Palace St.
Aurora, IL 60506m

Melissa Miller Nece, CPSA
2245-D Alden Lane
Palm Harbor FL 34683-2533

Bruce J. Nelson, CPSA
461 Avery Rd. E
Chehalis, WA 98532-8497

Barbara Newton, CPSA
Bina Designs
17006 106th Ave. S.E.
Renton, WA 98055

Connie Neylan
3586 E. Escalade Ave.
Salt Lake City, UT 84121

Monique Passicot
4406 17th St.
San Francisco, CA 94114

Scott Paulk
504 Brooktree Rd.
Knoxville, TN 37919

Stan Pawelczyk
306 Monroe Dr.
Piedmont, SC 29673

Don Pearson
7819 S. College Pl.
Tulsa, OK 74136

Mike Pease, CPSA
3210 Inspiration Pt. Dr.
Eugene, OR 97405

William Persa
4828 Scenic Acres Dr.
Schnecksville, PA 18078

Gail Piazza
123 St. Louis Dr.
Elkton, MD 21921

Benard A. Poulin
Ottawa, Canada K151W9

B. J. Power
3341 Power Ranch Rd.
Tombstone, AZ 85638

Richard Quigley
2260 Jefferson
Eugene, OR 97405

Teresa L. Ramirez
5317 Rosaer Place
Virginia Beach, VA 23464

Jan Rimerman, CPSA
P.O. Box 1350
Lake Oswego, OR 97035

Mike Russell
Act Attack
427 1st St.
Brooklyn, NY 11215

Mutsumi Sato-Wiuff
1423 N 19th St.
Grand Junction, CO
81501-6511

Sheila Scannelli
1648 Meadowlane SE
N. Canton, OH 44709

Heidi W. Schmidt
22 South Adams
Hinsdale, IL 60521

Allan Servoss, CPSA
1433 Hoover Ave.
Eau Claire, WI 54701

Dodie Setoda
6645 SW Dover St.
Portland, OR 97225-1005

Constance Moore Simon
307 Irving Dr.
Wilmington, DE 19802

Lee Sims, CPSA
735 Ridge Rd.
Lansing, NY 14882

Rita Mach Skoczen
609 Spartan Dr.
Rochester Hills, MI
48309-2526

Shirley Stallings
Mukilteo, WA 98275

Sabyna Sterrett
8429 Brook Rd.
McLean, VA 22102

Brad Stroman
2086 Rhoda Ave.
Mt. Joy, PA 17552

Christine Sykes
Sykes Illustrations
47 Tower Rd.
Plymouth, MA 02360

Proctor P. Taylor, CPSA
121 Valentine Dr.
Long Beach, MS 39560

Jeanne Tennent, CPSA
Birmingham, MI 48009

Raymond L. Tetzlaff
2785 Kipps Colony Dr. #206
St. Petersburg, FL 33707

Tanya Tewell
1697 Hollis Creek Rd.
Woodbury, TN 37190

Sharon Tietjen-Pratt
16008  33rd Ave. SE
Mill Creek, WA 98012

John Tolomei
1341 Bellomy St. #4
Santa Clara, CA 95050

Carol Tomasik, CPSA
4360 Suttle Dr.
Norton, OH 44203

Maggie Toole, CPSA
3655 Colonial Ave.
Los Angeles, CA 90066

Ronni Wadler, CPSA
8 Mardon Rd.
Larchmont, NY 10538

Kristin Warner-Ahlf
P.O. Box 241
South Cle Elum, WA
98943-0241

Jennifer Phillips Webster,
CPSA
22 Grandview Dr.
Radford, VA 24141

Laura Westlake
129 Weaver Rd.
West Sayville, NY 11796

Dena V. Whitener, CPSA
1986 Kramer Way N.E.
Marietta, GA 30062

Jane Wikstrand, CPSA
4115 Balsam St.
Wheat Ridge, CO 80033

Brenda J. Woggon CPSA
8785 Sanbur Trail NW
Rice, MN 56367

Elyse Wolf
Washington, DC 20016

Jaclyn Wukela
3016 Cane Branch Rd.
Florence, SC 29505

# INDEX OF ARTISTS

| | | | | | | |
|---|---|---|---|---|---|
| Kutch, Kristy A. | 60 | Pawelczyk, Stan | 43 | Stroman, Brad | 56 |
| LaMarche, Chris | 98 | Pearson, Don | 84 | Sykes, Christine | 78 |
| Leavitt, Donna | 48 | Pease, Mike | 124 | Taylor, Proctor P. | 125 |
| MacLean, Teresa McNeil | 113 | Persa, William | 95 | Tennent, Jeanne | 57 |
| Mahoney, Linda | 27 | Piazza, Gail | 121 | Tetzlaff, Raymond L. | 108 |
| Mallory, Marilynn H. | 112 | Poulin, Bernard | 131 | Tewell, Tanya | 132 |
| Mann, Karla | 97 | Power, B. J. | 70 | Tietjen-Pratt, Sharon | 22 |
| Mart, Susan | 79 | Quigley, Richard | 63 | Tolomei, John | 94 |
| Mateer, James K. | 41 | Ramirez, Teresa | 69 | Tomasik, Carol | 67 |
| McDonald, Ruth Schwarz | 40 | Rimerman, Jan | 23 | Toole, Maggie | 107 |
| McKay, Katherine | 33 | Russell, Mike | 87 | Wadler, Ronni | 133 |
| McLain, Gail | 101 | Sato-Wiuff, Mutsumi | 99 | Warner-Ahlf, Kristin | 24 |
| Mercer, Gail E. | 105 | Scannelli, Sheila | 42 | Webster, Jennifer Phillips | 49 |
| Mortenson, Susan | 122 | Schmidt, Heidi W. | 91 | Westlake, Laura | 25 |
| Mullarkey, Kimberly | 92 | Servoss, Allan | 32 | Whitener, Dena V. | 100 |
| Nece, Melissa Miller | 20 | Setoda, Dodie | 12 | Wikstrand, Jane | 53 |
| Nelson, Bruce J. | 26 | Simon, Constance Moore | 61 | Woggon, Brenda J. | 34 |
| Newton, Barbara | 21 | Sims, Lee | 130 | Wolf, Elyse | 116 |
| Neylan, Connie | 65 | Skoczen, Rita Mach | 28 | Wukela, Jaclyn | 77 |
| Passicot, Monique | 50 | Stallings, Shirley | 15 | | |
| Paulk, Scott | 35 | Sterrett, Sabyna | 44 | | |